REVISED SECOND EDITION

THE ART OF
STEAMPUNK

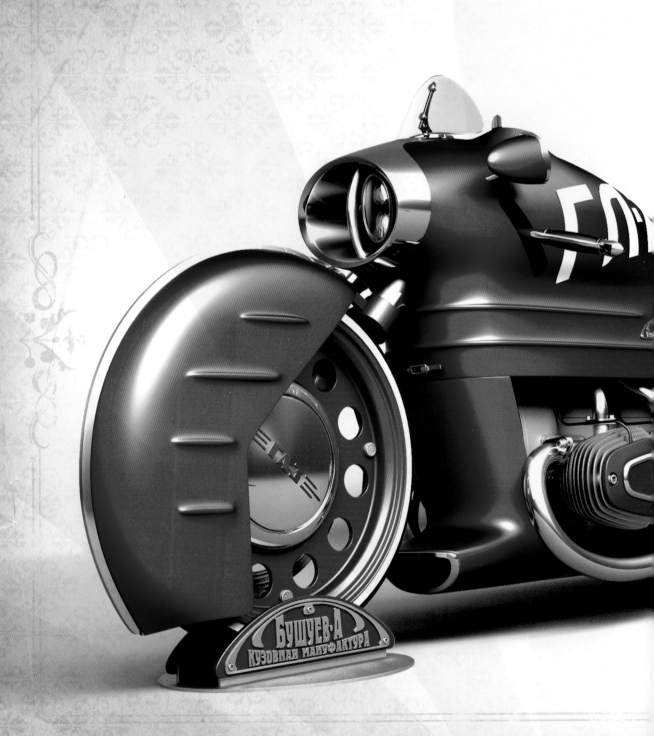

REVISED SECOND EDITION

THE ART OF
STEAMPUNK

Extraordinary Devices and Ingenious Contraptions
from the Leading Artists of the Steampunk Movement

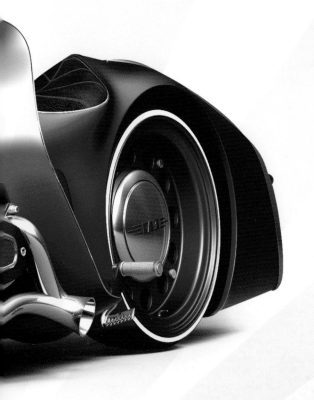

Art Donovan

Foreword by Dr. Jim Bennett,
Director of the Museum of the History of Science,
Oxford University, Oxford

Featuring an essay by G. D. Falksen

FOX CHAPEL
PUBLISHING

"Steampunk creations may be mechanical, sculptural, or purely decorative. The designs may be practical or completely fanciful. Whatever the application, the art celebrates a time when new technology was produced, not by large corporations, but by talented and independent artisans and inventors."

ART DONOVAN, AUTHOR AND CURATOR

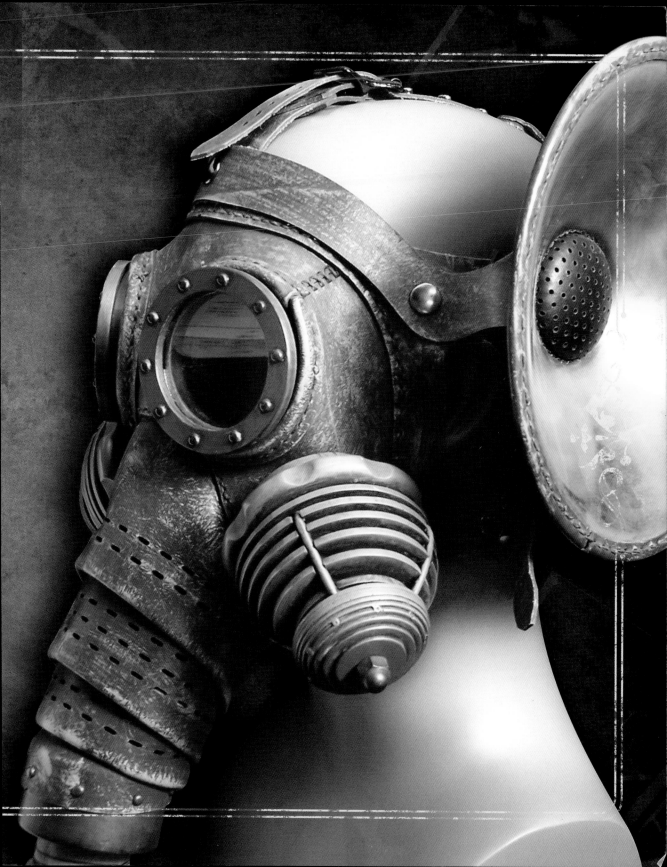

Cover art:
La Courtisane (courtesan), courtesy of Sam Van Olffen. Based on photos by Nadar.

The Art of Steampunk, Second Edition, is a revised edition, first published in 2013 by Fox Chapel Publishing Company, Inc., East Petersburg, PA.

ISBN 978-1-56523-785-8

Library of Congress Cataloging-in-Publication Data

Donovan, Art (Arthur W.), 1952-
 The art of steampunk / Art Donovan ; foreword by Jim Bennett. -- Second Edition.
 pages cm
 Includes index.
 Summary: "Welcome to the world of Steampunk: a unique fantasy version of nineteenth century Victorian England imbued with today's technology, resulting in devices and contraptions that seem to have sprung from the mind of a mad twenty-first century scientist. The "steam" refers to steam power - as in fire-breathing machines of antique locomotion. The "punk" is an important reference to an outsider attitude. In The Art of Steampunk, 2nd Edition, you'll discover the captivating and dynamic world of this emerging genre through the creative vision of today's leading Steampunk artists, all featured in the world's first museum exhibit of Steampunk, held at The Museum of the History of Science at Oxford University in England. No longer satisfied with the plastic design of today's mass-produced products, these artists are crafting a romantic new standard for modern goods by applying the characteristics of Steampunk. Their artwork consists of everything from jewelry and watches to light fixtures and clocks, every piece demonstrating hours of painstaking work and unlimited devotion. You will find that many of the artists are as unique and colorful as their masterpieces, often adopting alter egos of Victorian mad scientists and world explorers, allowing themselves to become fully immersed in the imaginative and exciting world of Steampunk. This expanded edition has added artist profiles and a look at what is happening in the world of Steampunk since the exposition. "-- Provided by publisher.
 ISBN 978-1-56523-785-8 (pbk.)
 1. Art and technology--History--21st century. 2. Art, Modern--21st century--Themes, motives. 3. Technology in art. 4. Steampunk culture. I. Title.
 N72.T4D66 2013
 709.05'107442574--dc23
 2013002273

To learn more about the other great books from Fox Chapel Publishing, or to find a retailer near you, call toll-free 800-457-9112 or visit us at *www.FoxChapelPublishing.com*.

Note to Authors: We are always looking for talented authors to write new books. Please send a brief letter describing your idea to Acquisition Editor, 1970 Broad Street, East Petersburg, PA 17520.

Printed in China
First printing

Dedication

With love, for my beautiful wife, Leslie Tarbell Donovan, without whose talent and vision, this exhibition and book would not have been possible.

Acknowledgements

I would like to acknowledge the generous support of the following individuals and organizations and thank them for their gracious support.

* Anne Surchin, American Institute of Architects
* The American Hotel
* Barber-Wilson Co, UK
* Bethany Peters
* Carleen Ligozio
* Cory Doctorow
* Deidre Woolard
* Dr. Jim Bennett, Director, Museum of the History of Science
* The Hamptons Antique Galleries
* Joanne Molina
* Laura Ashby, Museum of the History of Science
* Lauren Sloan Weisman
* Sam Van Olffen
* Sara Brumfield
* Sydney Padua
* Margaret Hauser, Museum of the History of Science
* Nick and Owen, Museum of the History of Science
* Nick Ottens
* The Sag Harbor Yacht Yard
* Whites Pharmacy

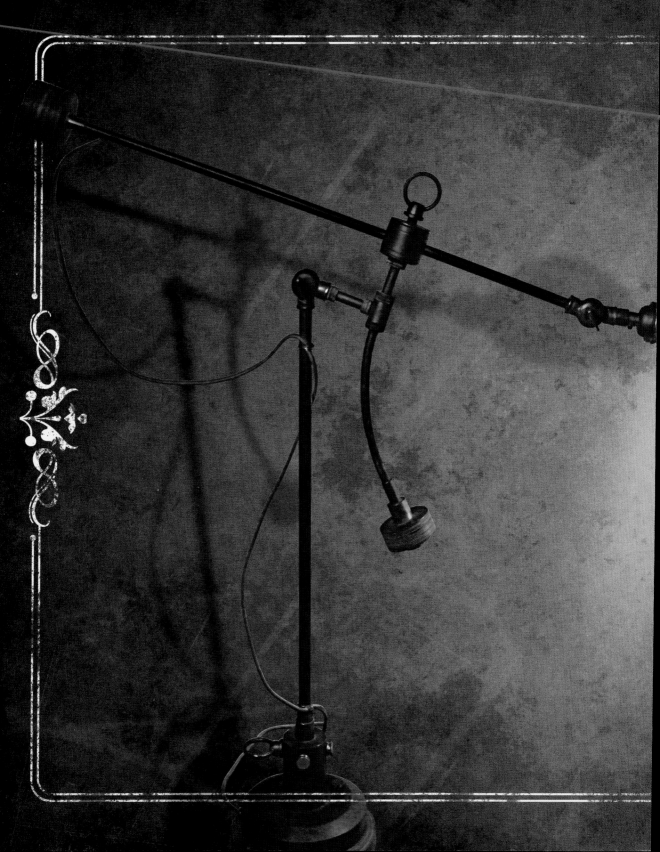

Contents

PUBLISHER'S FOREWORD

About five years ago, we started hearing buzz about Steampunk at the European bookfairs. Although new to us, we were intrigued by the concept of combining the literature, art, and science of the past with modern technology. We started researching the genre to determine how popular it was in America, sending Peg Couch, one of our editors, on an exploratory trip to the Steampunk World's Fair. What we found there was an incredible community of creative individuals who wanted nothing more than to share their work. She said, "When I arrived at the show, I felt as though I had stepped into another world. The crowd of over 3,000 attendees was buzzing, and there was a festival-like feel to the event with people walking on stilts, dressed as time travelers, vaudeville entertainers, inventors, and mad scientists. There were sights for the eye everywhere you turned!"

The honor of publishing truly innovative subjects often falls to independent publishers such as ourselves. With our love of craftsmanship and appreciation for authentic work, we fell in love with the ingenuity and creativity of the Steampunk community. Having decided that we needed to create a book on Steampunk art, the search for the right author began. It was difficult to find someone with good design sense across the many types of Steampunk art.

I can't praise Art Donovan enough. An artist in his own right with an impressive client list, Art had just finished curating the first-ever museum exhibition of Steampunk art at considerable personal cost. The sheer joy and delight Art takes in finding high-quality work by other Steampunk artists was the driving force behind the exhibit and this book. The work from Art's recent exhibition was dynamic, intriguing, and like nothing we had seen before. Most importantly, the selection worked wonderfully together. It was international and wide-ranging in scope, and at the same high level of craftsmanship.

By the time the first edition was on press, the buzz about Steampunk was growing. We saw it walking the aisles of the Javits Center during the 2011 Book Expo America. It was being featured in sci-fi/fantasy books and graphic novels, and we were encountering it more and more frequently online. Ultimately, we knew we had caught on to a trend that was about to grab hold of the world, and we couldn't wait to see what would happen next.

The years 2010 and 2011 are significant in that, according to a recent Social Sentiment Index from IBM, they mark a significant jump in Steampunk's popularity. At the same time the first edition of *The Art of Steampunk* was being developed and printed, IBM reports the online community experienced a 300 percent jump in Steampunk fashion-related posts.

More recently, IBM notes Steampunk's growing presence on popular social media

sites like Facebook, Twitter, and Pinterest. According to *Forbes* magazine contributor Barbara Thau, this points to a not-so-distant emergence of Steampunk in the mainstream market. "These are telling indicators that the steampunk trend will expand from small manufacturing on sites such as Etsy and collections from high-end designers like Prada and Alexander McQueen, to mass production by major fashion labels, jewelry and accessories makers, and to national chains such as H&M and Zara."

Time notes that mainstream fashion trends usually appear on couture runways before they arrive in a local department store, and that Steampunk also follows this formula. "For steampunk, the high-end influence is already out there. For his spring 2010 couture show, John Galliano designed a parade of looks for Christian Dior with nods to early 20th century influences—including corsets, top hats, flowing fabrics, layers of lace and Frankenstein-esque hair and makeup…" Alexander McQueen and Prada also featured Steampunk looks in recent collections.

While the Internet and fashion industry began feeling the Steampunk influence, Fox Chapel experienced the growth of the genre through the popularity of *The Art of Steampunk*. We quickly sold out of our first inventory shipment and ordered a reprint. Soon, it became apparent that a reprint of the original title was not enough. In less than a year since the book's first printing, Steampunk

had grown and evolved—known Steampunk artists were creating new, astounding works, and others were beginning to explore the Steampunk aesthetic for the first time with amazing results. It was clear that a second edition was needed to highlight the continued growth of this distinctive genre.

IBM predicts 2014 as the year for Steampunk, and once again, we find ourselves matching the trend with this second edition of *The Art of Steampunk*, filled with wonderful new lighting creations from Art Donovan and the work of eight new artists that Art was led to by his boundless enthusiasm.

There is no doubt Steampunk will continue to grow and change, but we hope you will appreciate the snapshot we have captured here as one moment in the history of the genre. Personally, I have always found that the artists working in a field before it becomes popular possess a certain purity and sense of style that is hard to match. I hope you will enjoy these exquisite pieces of art with the same sense of delight and wonder that Art has brought to our desks in preparing this volume.

Happy reading!

Alan

Alan Giagnocavo
Publisher, Fox Chapel Publishing

SOURCES
IBM Social Sentiment Index: *www.ibm.com/analytics/us/en/conversations/social-sentiment.html*
Skarda, Erin. "Will Steampunk Really Be the Next Big Fashion Trend?" *Time.*
Thau, Barbara. "IBM Says Steampunk Looks Will Be All The Rage at National Chains This Year." *Forbes.*

11

ABOUT THE AUTHOR

Art Donovan

Opposite *Siddhartha Pod Lantern,* 2008, 62" x 23" (1575 mm x 585 mm), mahogany, glass, and brass. This piece was Donovan's first Steampunk creation.

Art Donovan was born and raised in New York City. With more than thirty years of experience in the art industry, Donovan was once the senior designer and head illustrator for Donald Deskey Associates, the company responsible for designing the interior of Radio City Music Hall. Since 1990, Donovan has worked for Donovan Design, a company he and his wife, Leslie, founded. Donovan creates handcrafted lighting fixtures and illuminated sculptural objects for the company. The Donovans have an impressive client list that includes groups and companies such as Tiffany & Co., New York City; The University of Baltimore, Maryland; Churchill Downs, Kentucky; Benetti Luxury Yachts, Italy; St. Francis of Assisi Cathedral, Nevada; Four Seasons Resorts Villas, St. Thomas; Nine Zero Hotel, Boston; and Disney Cruise Lines, along with countless private residences, restaurants, and casinos around the world.

Donovan first encountered Steampunk on the Internet a few years ago. He was excited by the style because it was like nothing he had ever seen before, and focused on topics such as history, science, and science fiction, subjects in which he has always held an interest. Donovan soon began designing Steampunk light fixtures, embracing the style that was so far removed from anything he had ever done previously.

Donovan's interest in Steampunk did not end with his creation of new projects. Instead, it led him to make connections with other Steampunk artists and, eventually, to become the curator of a Steampunk exhibit at the Hamptons Antique Galleries in 2008 and the Steampunk exhibition held at Oxford University's Museum of the History of Science. The exhibition, which ran from October 2009 to February 2010, brought together renowned Steampunk artists from around the world. Since the exhibition, Donovan has continued to create Steampunk masterpieces and is constantly working to bring Steampunk to the attention of others.

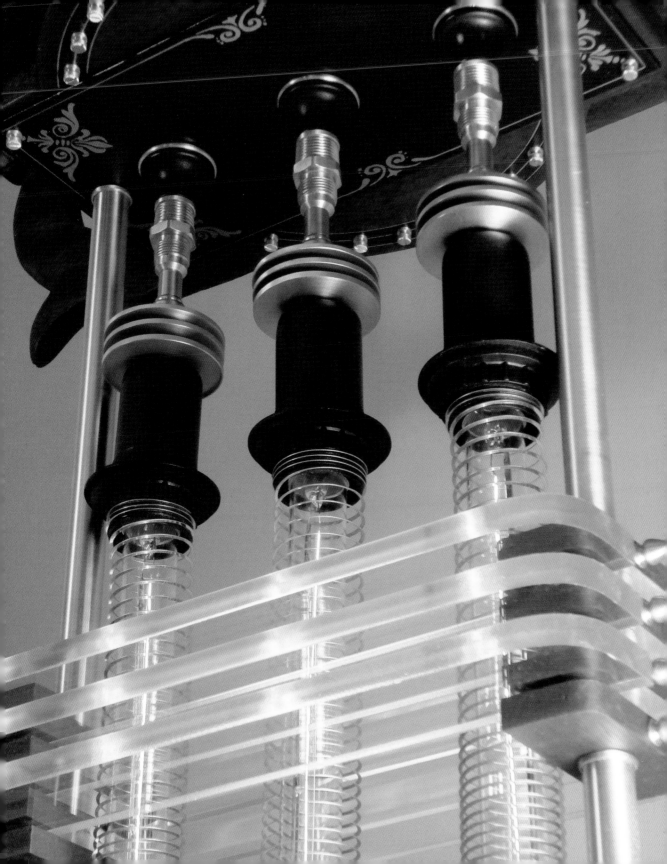

14

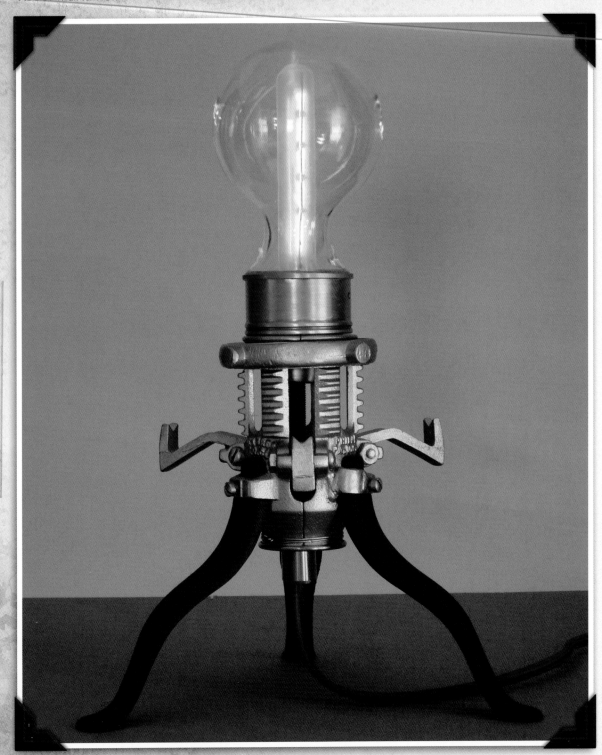

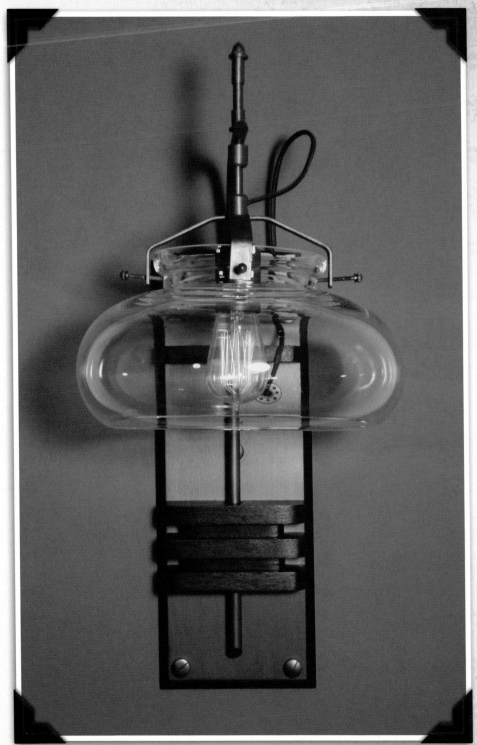

Opposite *Mr. Peanutski*, 2008, 13.5" (340 mm) tall, brass, steel, modded light bulb.

Left *Oxford Station Lantern*, 2010, 18" x 13" (455 mm x 330 mm), antique satin brass, mahogany, steel, hand-blown glass globe. This Steampunk lamp is inspired by the lamps found outside of New York City's Grand Central Station.

16

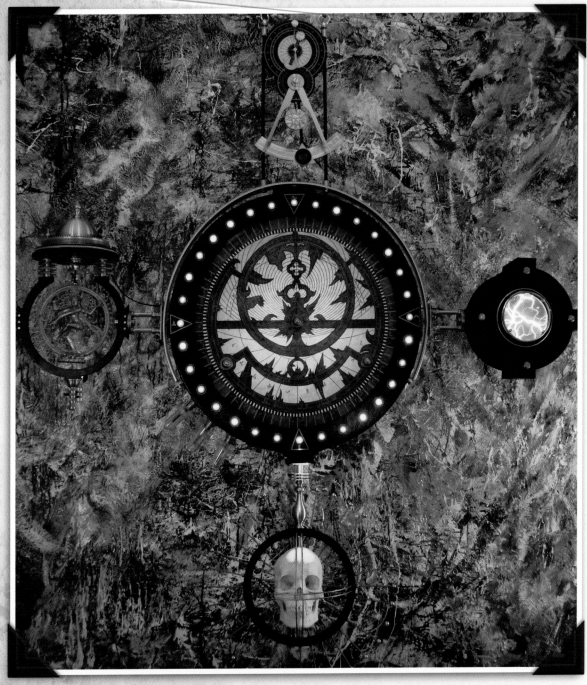

Shiva Mandala, 2009, 72" x 72" (1830 mm x 1830 mm).
Representing the cycle of life, the *Shiva Mandala* is
made up of five distinct pieces: the center *Astrolabe*
and four surrounding "planets."

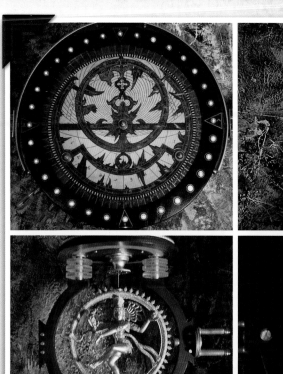

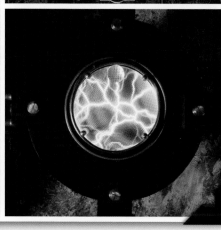

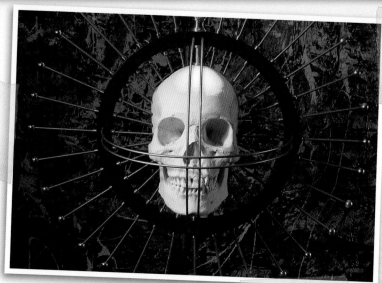

Top Left *Astrolabe*. The *Astrolabe* is the central piece of the *Shiva Mandala* and is a reproduction of a thirteenth century Persian device.

Top Right *All Seeing Eye*. The upper planet of the *Shiva Mandala* contains Masonic symbols.

Middle Left *Nataraja Shiva*. Donovan created this planet of the *Shiva Mandala* so that it slowly rotates.

Middle Right *Plasma Disk*. The electric blue *Plasma Disk* is the right-hand planet of the *Shiva Mandala*.

Bottom *Craniometer*. The *Craniometer* is the lower planet on the *Shiva Mandala*.

17

18

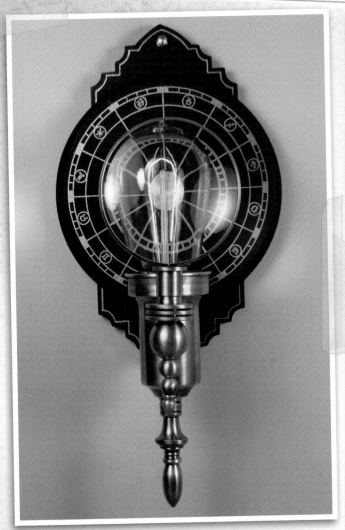

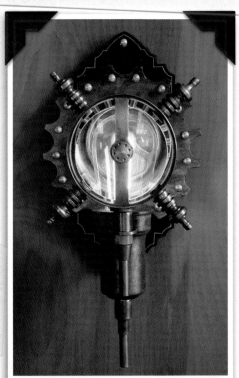

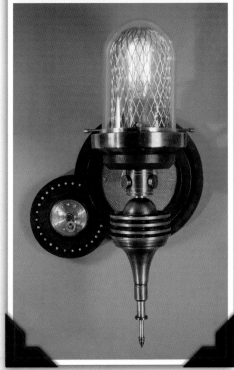

Above *Parrish Carriage Lantern*, 2008, 18" x 11" (455 mm x 280 mm), brass, mahogany. This lantern features hand-painted symbols to add a unique detail.

Above Right *Sister to the Parrish Carriage Lantern*, 2008, 18" x 11" (455 mm x 280 mm). This lamp is a twist on the *Parrish Carriage Lantern*, featuring more ornate and machine-like elements.

Right *Parrish Carriage Lantern III*, 2008, 18" x 11" (455 mm x 280 mm). The third lamp in the *Parrish Carriage Lantern* series displays a clock at its base.

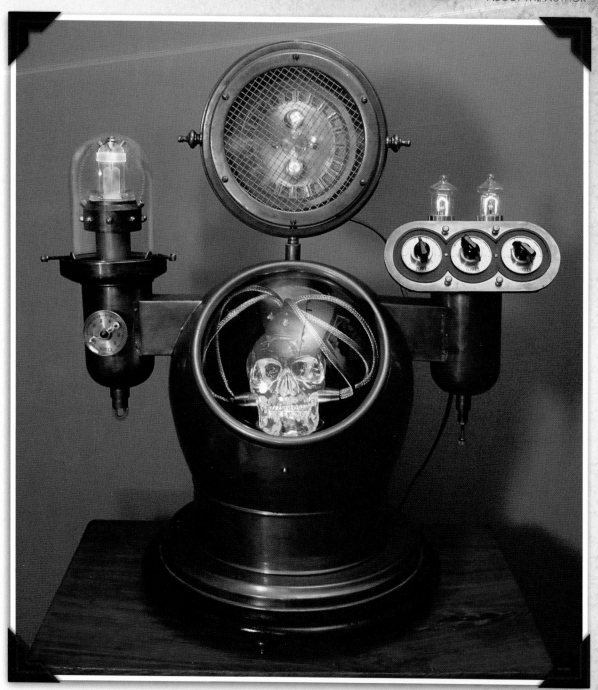

The Electric Skull, 2009, 24" x 24" (610 mm x 610 mm).
Donovan took inspiration for this piece from a nautical
compass-like device often found on Victorian ships.

Creating After Oxford

Author Art Donovan continues to be a creator of extraordinary Steampunk lighting fixtures and illuminated sculptural objects. The items featured here were all completed after the close of the Oxford Steampunk exhibition.

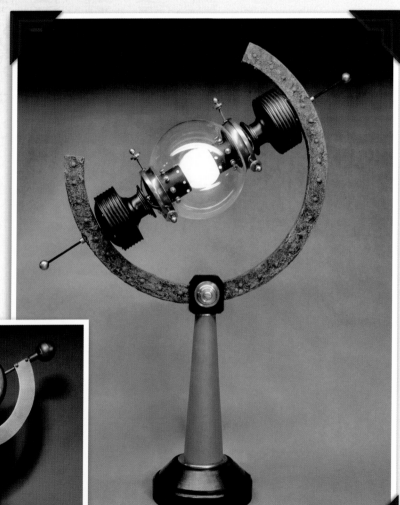

Right *Arc Light*, 25" (635 mm) tall, maple, steel, brass, glass, incandescent bulb.

Below *The Sultan Jack*, 30" (760 mm) tall, 18" (455 mm) wide, brass, maple, pine, glass.

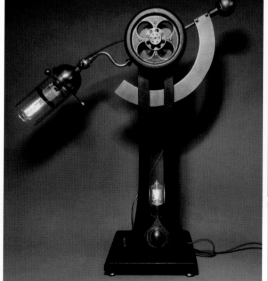

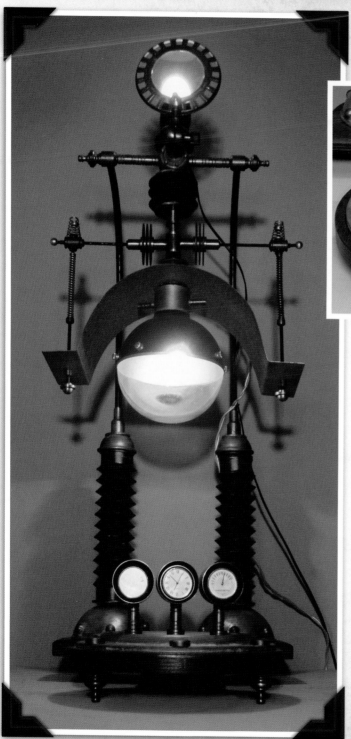

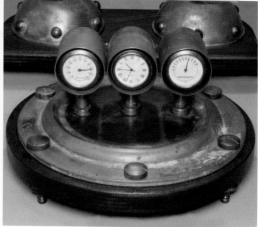

Steampunk Weather Station, brass weather gauges, maple, brass, steel, hand-modified globe bulb, bronze.

21

Right *Steampunk Table Clock*, 13" (330 mm) tall, auto transmission bezel, maple, brass, handmade brass hands.

Bottom Left *Rusted Steampunk Wall Clock*, 31" (785 mm) diameter, brass, steel, maple, hand-applied rust finish (acrylic), handmade brass hands.

Bottom Right *Steampunk Wall Clock*, 31" (785 mm) diameter, steel, brass, quartz movement, handmade brass hands.

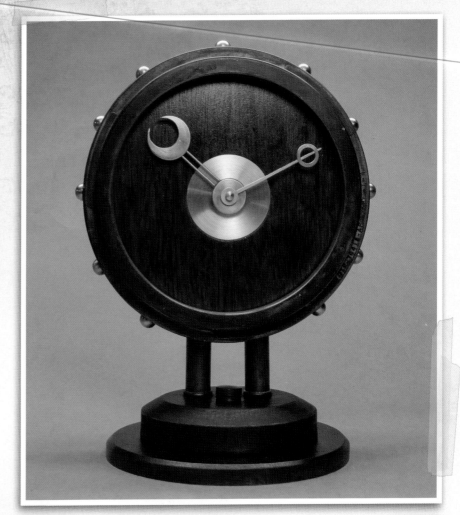

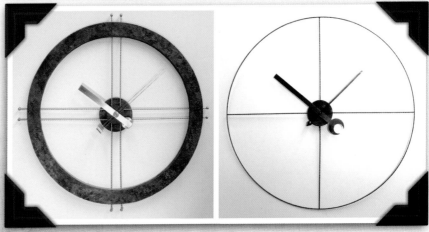

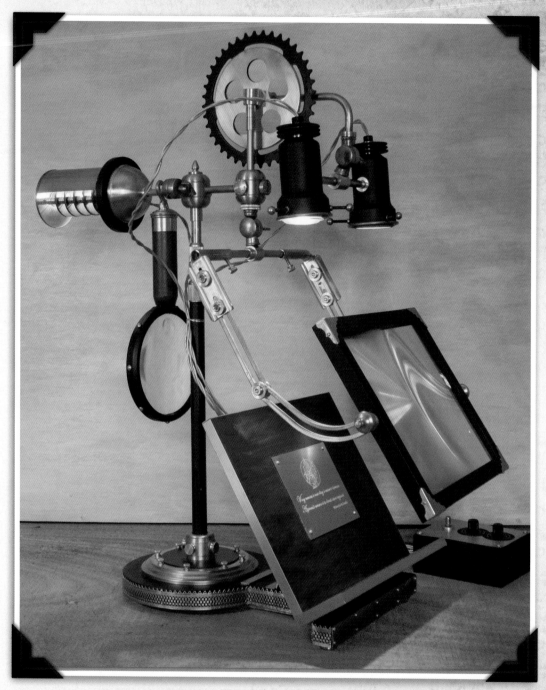

The Ferryman—Reading and Research Lamp, 22" (560 mm) tall, 14" (355 mm) wide, maple, brass, steel, lenticular lens, UV and incandescent bulbs.

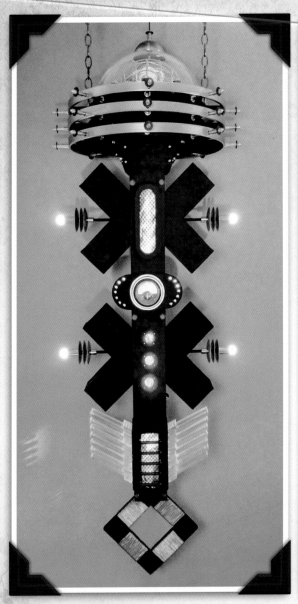

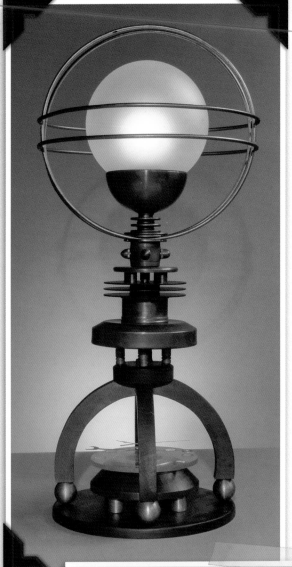

Above Left *Ravi Palace*, 84" (2135 mm) tall, 28" (710 mm) wide, maple, plywood, brass, steel, bronze, dichroic lenses, polycarbonate Lexan® resin, clockwork movements, UV, CFL, and incandescent bulbs.

Above Right *Petite Cosmo Table Lamp with Moon Phase Clock*, 19" (485 mm) tall, 10" (255 mm) diameter, glass, brass, steel, moon phase clockwork with hand-painted dial.

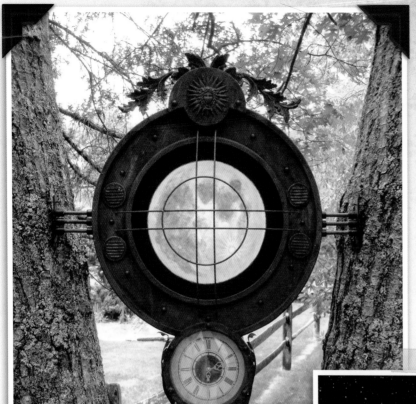

Left *Outdoor Mandala*,
40" (1015 mm) tall, 12" (305 mm)
deep, maple, spun filament
fiberglass, paint, hand-applied
rust finish (acrylic), brass, steel,
UV and incandescent bulbs.

Below *The Astronomer's Lamp*,
13" (330 mm) tall, brass, steel,
hand-painted lunar dome.

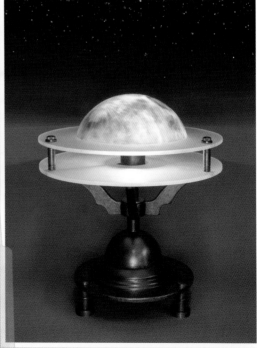

PROVENANCE

25

FOREWORD

Top Right This program was handed out to guests attending the Oxford Steampunk exhibit.

Bottom Right More than 70,000 visitors walked through the entrance of the Museum of the History of Science to view the Steampunk exhibit.

When Art Donovan suggested an exhibition of Steampunk art at the Museum of the History of Science, we quickly realized that here was an opportunity not to miss. Many science museums today emphasize the importance of their work for the public understanding of contemporary science. This is a policy we have difficulty following, because the material we preserve and display is renowned for its antiquity. While, as historians, we believe that the present depends on the past and cannot be fully appreciated without a historical perspective, we are also aware the understanding of the material world in the past could be profoundly different from ours. Interpreting this past understanding in terms of modern science can be deeply distorting.

Because the original intellectual context for much of our collection is often unfamiliar to visitors, and a modern interpretation often inappropriate, we try to emphasize the value of a variety of approaches and appreciations. We can be more relaxed about understanding "the science" than many museums, seeing this as only one possible approach, while others might be aesthetic, social, historical, biographical, cultural, and so on. We want visitors to enjoy our objects in a variety of ways and not to feel alienated if the theoretical content of the science is not for them. We want them to value what they enjoy about engaging with our remarkable collection.

So, a Steampunk exhibition was perfect. Engagement with the aesthetic aspects of science, past and present, had already led us to a strong art component in our exhibitions and to a current in our program branded as "ART@MHS." Steampunk brought two additional features. First, the movement had adopted a visual culture originally exemplified by many of our instruments. Second, Steampunk had brought these aesthetic, material, and artisanal values enthusiastically into the present day. We quickly realized Steampunk did not aim at a nostalgic recreation of a vanished past and its devices were both imaginative and contemporary. So the exhibition could be an opportunity to achieve that elusive combination we sought—historical appreciation and contemporary relevance.

The emphasis of this book is properly on the Steampunk art from the exhibition and on the artists who made it, but the museum added a component to the show that made the most of the opportunity we

26

had recognized. A room through which the visitors exited contained original Victorian and Edwardian instruments and machines that exemplified the roots of Steampunk art. The reactions of our visitors supported the museum's policy of the varieties of appreciation. Objects that would scarcely have been noticed elsewhere in the museum were examined with care and pleasure. Instruments that would have been dismissed as beyond understanding were embraced for their sculptural and decorative qualities; they were enjoyed as relics of a past visual culture. In the gallery devoted to Steampunk art, the visitors had engaged easily with the display, had savoured and valued the pleasure of seeing work that was thoughtful, original, finely made, and amusing, and they carried that sensibility into the gallery of historic instruments. No amount of exhortations from us about varieties of appreciation could have achieved this, but here we could see the policy working. Steampunk gave us that opportunity.

— Dr. Jim Bennett
*Director, Museum of the History of Science,
Oxford University, Oxford.*

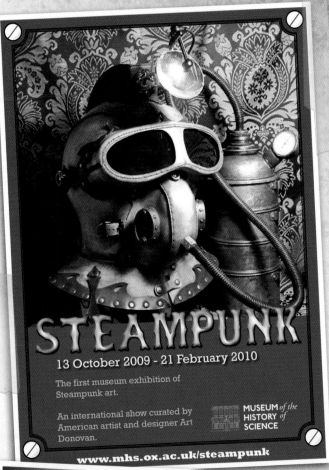

27

Right The Museum of the History of Science created a special sign that was added to the entrance to the museum while the Steampunk exhibit was running.

Below From October 2009 to February 2011, visitors to the Museum of the History of Science could walk through Steampunk-themed galleries and attend special events. This program shows the list of events for October through December 2009.

Opposite Designed by Art Donovan, this poster was used to advertise the exhibit.

28

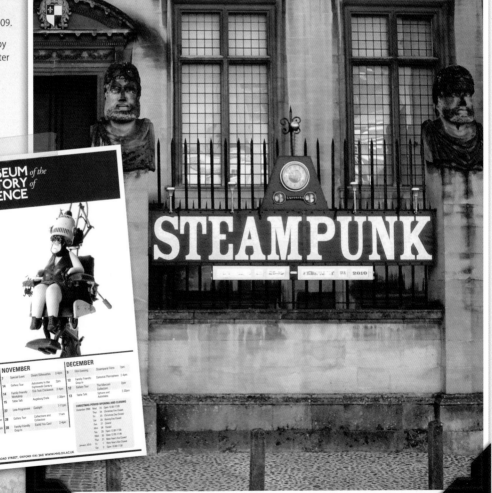

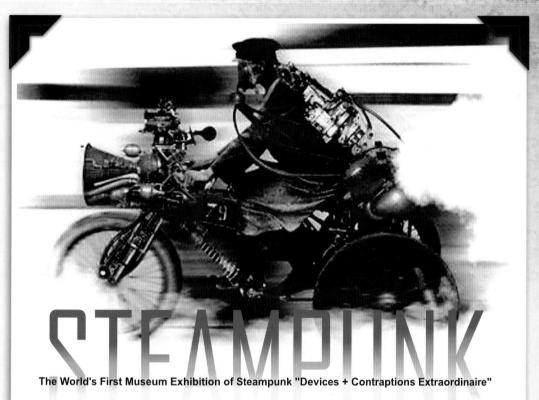

STEAMPUNK

The World's First Museum Exhibition of Steampunk "Devices + Contraptions Extraordinaire"

29

The Museum of the History of Science at the University of Oxford, UK

October 13, 2009 through February 21, 2010

Artists hailing from:
Japan
Canada
Belgium
Australia
Switzerland
The Netherlands
The United States
The United Kingdom

Presented by Dr. Jim Bennett and Curated By Art Donovan

www.steampunkmuseumexhibition.blogspot.com

Art by Sam Van Olffen

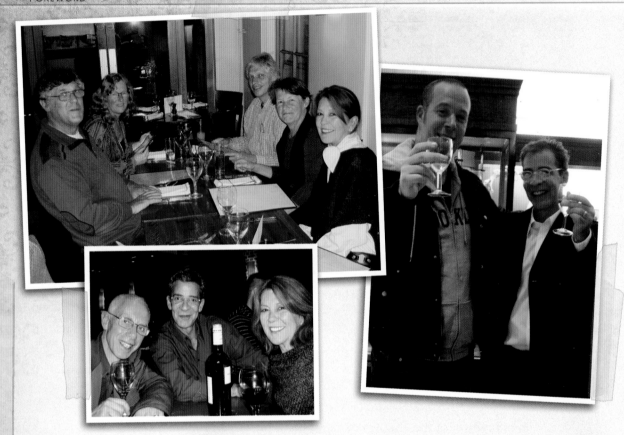

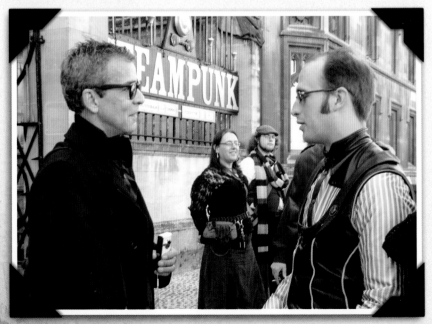

30

Above Left Artist Jos de Vink (left) celebrated the success of the exhibition at a dinner with his family, fellow artist Art Donovan, and Donovan's wife, Leslie (bottom right).

Above Right The exhibit showcased artists from around the world, such as Stephane Halleux (left) from Belgium and Art Donovan (right) from the United States.

Above Middle Dr. Jim Bennett, pictured here with Art and Leslie Donovan, helped the Oxford exhibition become a reality through his role as the Director of the Museum of the History of Science.

Right Art Donovan with James Richardson-Brown, one of the event's exhibitors.

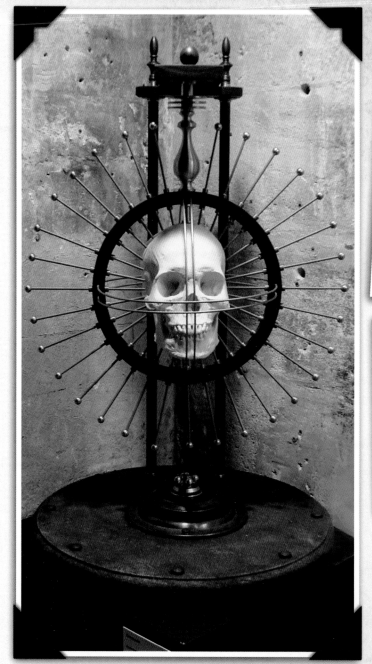

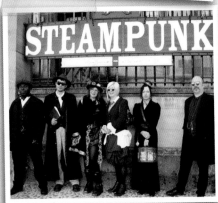

Left *Steampunk Craniometer*, 2007, 24" (610 mm) tall, 19" (485 mm) diameter, brass, plaster, and solid mahogany, suspended from a custom, rust-applied mahogany armature.

Top The exhibit not only showcased Steampunk art and design, but some Steampunk fashions as well.

Above In the spirit of the exhibition, many Steampunk fans came to the museum dressed in costume.

INTRODUCTION

From October 13, 2009, to February 21, 2010, it was my great honor to act as curator for the Steampunk exhibition held at the University of Oxford's Museum of the History of Science. The event was the first museum exhibition of Steampunk art ever, and featured work from eighteen of the most renowned Steampunk artists from around the world. More than 70,000 guests arrived at the museum during the exhibition's four-month span to attend lectures, workshops, and holiday events that

all revolved around Steampunk. Since then, it has been my joy to watch the evolution of the Steampunk genre as artists like those featured on pages 39–69 and those from the Oxford exhibition continue to produce extraordinary pieces of exquisite quality.

For Steampunk enthusiasts, an event with the magnitude of the Oxford exhibition has been a long time coming. Although most people have never heard of it, on the Internet, Steampunk has grown so wildly popular that, in less than a year, it has spawned an actual philosophy and lifestyle among its fan base. Steampunk has already influenced everything from product design to fine art and fashion.

Steampunk is a unique fantasy version of nineteenth century Victorian England, now imbued with high-tech digital devices, fantastic steam-powered machines, and all manner of surreal electro-mechanical contraptions that could only have been conjured by a mad twenty-first century scientist. The "steam" refers to steam power—as in the living fire-breathing machines of antique locomotion. The "punk" is an important reference to an outsider attitude. In Steampunk, this attitude manifests itself in the form of the lone wolf artist, the Do-It-Yourself (DIY) craftsman, and the amateur engineer, who are not beholden to any

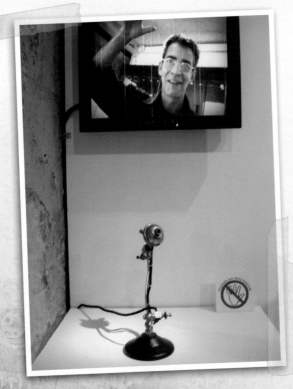

contemporary style or ideology. You can bet you won't be seeing this kind of design in your next *Design Within Reach* catalog—and that's just the way the Steampunks want it.

Once you know where to look, Steampunk design is familiar. By reading H. G. Wells, Jules Verne, or Mary Shelly, or by seeing movies such as *Brazil* or *The League of Extraordinary Gentleman*, you may already have had a peek into this ingenious style. Hollywood has embraced Steampunk and often uses it as a plot foundation for its films (think *Wild, Wild West*). As far as Steampunk's Internet popularity is concerned, you can thank today's young savvy computer geeks, bloggers, gamers, authors, and artists. Obviously, these creative individuals are not Luddites. They celebrate modern technology, but firmly believe that the design of modern products like the iPhone and iPod can't possibly compete with the luxurious design of the early "Victorian wonders" of technology.

Although it's technocentric in styling, Steampunk design is definitely not just a "boy's club" of enthusiasts. Its fans and creators are equally divided among women and men, young and old alike, from around the world. Websites dedicated to the style, such as Sara Brumfield's *The Steampunk Home*, feature the most current "New Victorian" designs applied to everything from architecture and product design to home accessories.

No longer satisfied with the injection-molded plastic design of today's mass-produced products, Steampunk artists are crafting a romantic new standard for modern goods by taking traditional nineteenth century materials and applying them to twenty-first century technology. They reach to the past and the future, combining elements of both into designs that are richly pleasing to the eye and as technologically up to date as the latest computers, music players, and stereo systems. These artists prefer the "transparent" honesty of the handcrafted object, and—with a surprising disregard for the *de rigueur* styling

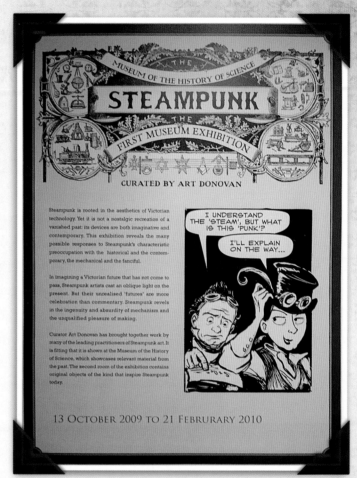

Above This sign was hung at the entrance to the Steampunk exhibit, and helped visitors who might be encountering Steampunk for the first time gain some understanding of the style.

33

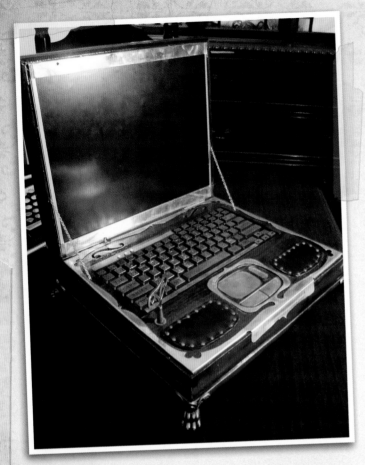

34

Above *Datamancer Steampunk Laptop*, Richard Nagy, 2007, 14" x 16" (355 mm x 405 mm), wood, brass, copper, clock gears, glass.

Right *Antiqua Perpetual Calendar*, Vianney Halter, 1998, created at La Manufacture Janvier (Sainte-Croix), 1.6" (400 mm) diameter, .5" (110 mm) thick, rose gold.

of contemporary fashion—they boldly embellish their work with all manner of historic design references and ornate technological flourishes.

Richard Nagy, whose stunning work can be found within the pages of this book, creates modded laptops that are technological Steampunk jewels. Imagine sitting in Starbucks and opening up one of Nagy's slim solid mahogany laptops, complete with studded leather hand rests, brass scroll work, elegant cast-claw feet, and solid brass antique keys. For added authenticity, Nagy provides

a large antique key that is actually used to turn the laptop on. With a few twists of the key—accompanied by the anticipated and satisfying clicking sound—Nagy's laptop fires up to perform as well as the best state-of-the-art computers on the market.

These computer designs, as unique and beautiful as they are, beg the obvious question: Why would anyone want to design a computer or laptop to look like this in the first place?

In the world of Steampunk, machines must not only be practical, they must be pieces of art. During the Victorian era, objects were not only meant to be impressive in function, but in form as well. Steampunk art seeks to continue this philosophy by celebrating the object that is created. In the mind of a Steampunk artist, a computer should not only operate at the highest speed possible, it should be richly decorated with the finest woods and metals. Music from an iPod should not be heard through plastic headphones, but should be projected through a shining brass gramophone horn.

It is true, due to the modern methods of mass production and the need to cheaply produce billions of units, modern design now suffers from an androgynous "digital silhouette" whereby one cannot visually tell the difference between a cell phone and a remote, or even a flat screen TV and computer. To counter the current generic look of modern products, Steampunk artists spend hours handcrafting their pieces so that each one takes on its own

style and flavor. This dedication to unique individuality can be seen in everything from handmade piston-driven contraptions to exquisitely rendered fantasy devices and

It's important to realize, however, that Steampunk design is not simply relegated to fashionable decorations and digital devices. Jos de Vink, an artist and mechanical engineer

> ## "Steampunk design is not simply relegated to fashionable decorations and digital devices."

designs in exotic woods and gold.

Steampunk is such a wide and democratic philosophy with influences of fantasy literature, Victorian science, and nineteenth century spiritualism, that there is no single way to approach Steampunk art and design. Whether they're decorative or utilitarian objects, however, Steampunk designs are individual artisan creations. They are, intrinsically, sculptural pieces of art and lend themselves to any environment, be it extreme contemporary or traditional.

Swiss timepiece master Vianney Halter, who presented his collection of Steampunk watches at the Oxford exhibition, has demonstrated how seriously Steampunk has influenced even the most traditional of design disciplines. Halter's wristwatch, *Antiqua Perpetual Calendar,* is a handcrafted relic of the future, complete with multiple gauges and a sapphire crystal back that displays the clock works. The watch, which took Halter more than 900 hours of intense labor to produce, looks as if it has been taken from the cockpit of an antique locomotive.

from the Netherlands whose work can also be found on the pages of this book, is currently experimenting with motors and engines that run solely on heat. His Steampunk Stirling engines are beautifully handcrafted from solid brass and use the simple heat from a candle or tea light to power their piston-driven motors. Using only the small differential of hot and cold

35

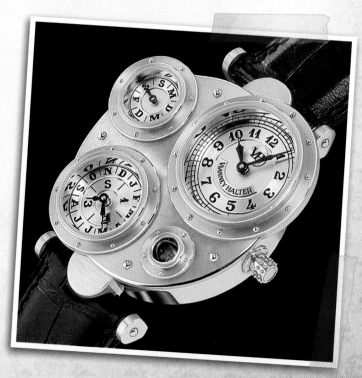

THE EVOLUTION OF STEAMPUNK

Since I curated the 2009–2010 Oxford Museum exhibition, Steampunk has grown immensely in popularity throughout the world, developing from a primarily Internet-based genre into a form with a prominent impact on today's popular culture. The influences of Steampunk can be seen everywhere from film to strutting the runways of Paris and Milan and also in architecture and home décor.

Of course no discussion about the influence of Steampunk would be complete without mention of its use as an art form. Imbedded in Steampunk's very description is a demand for astounding aesthetics and visual impact, opening the door for artists to break away from the mass market, contemporary designs that are so imbedded in our culture. The creation of Steampunk art requires imagination, historical research, patience, and often an incredible amount of time, resulting in extraordinary and unique pieces that demand attention.

The work of the artists featured here exemplifies some of the very best in Steampunk art and design. Each artist sets the standard for his or her involvement—be it jewelry, sculpture, lighting, painting, or digital art. The designs are original, diverse, and truly exquisite. Additionally, almost all of the pieces were created in the time since the Oxford exhibition, richly illustrating how quickly Steampunk art evolves. Steampunk is a grand global theater of fantasy and will continue to resist strict definition as each unique artist brings his or her own experience to the table.

—Art Donovan

"Floating Time" necklace, 2012, 6" (15cm) long, 3" (7.5cm) wide at widest point, vintage brass elements, watch parts, resin, 20" (51cm)-long brass chain. Collection of the artist.

ALL ANN PEDRO PHOTOS BY KEVIN HAGAN.

Ann Pedro

In 2006, Ann was the recipient of the Eunice Miles Scholarship from the Gemological Institute of America (GIA) and received her Accredited Jewelry Professional diploma in 2007. Her work has been featured in more than twenty-five museum and gallery exhibitions throughout Connecticut, Massachusetts, Pennsylvania, and Florida.

She is the recipient of several awards for her jewelry designs, including two Purchase Awards from the Slater Memorial Museum in Norwich, Connecticut, which has two of her pieces in their permanent collection.

My journey into the world of Steampunk began when I came across a Steampunk book. I had never heard of Steampunk before, but was drawn to the images I saw and knew, with my jewelry skills, I could create pieces in the Steampunk genre. I had been designing jewelry for more than twenty-five years. I started creating and haven't stopped.

Several months later, I participated in the unique exhibition "Nemo's Steampunk Art and Invention Gallery" for which I designed three "Medallions of Neptune."

Jewelry design is my creative medium of choice, and my steampunk designs are some of the work with which I am most pleased. I like the idea of "recycling the past" in new and creative ways. Using vintage pieces of watches and clocks is especially appealing. As I work on each piece, I like to think about the previous owners of the items I use. I appreciate the craftsmanship and design of the original items and like knowing that I am fashioning them into objects of adornment to be enjoyed by new generations of collectors.

39

Top Left *Pendant*, 2012, 6¼" (16cm) long, 1¾" (4.5cm) wide, vintage brass elements, watch parts, brass dangle beads, resin, base metal. Collection of the artist.

Top Right *Necklace*, 2012, 5¼" (13.5cm) long, 2¼" (5.5cm) wide, 24" (61cm)-long brass chain, vintage brass elements, copper, spring, brass hex nut, sterling silver. Collection of the artist.

Bottom Left *"Key of Time" pin*, 2010, 2¾" x 1½" (7 x 4cm), vintage key, base metal, vintage brass clock hand and gear, watch face. Collection of the artist.

Bottom Right *Necklace*, 2011, 4" (10cm) long, 2" (5cm) wide, 1½" (4cm) deep, vintage brass elements, copper, watch parts, base metal, 20" (51cm)-long 18 karat yellow gold filled chain. Collection of the artist.

40

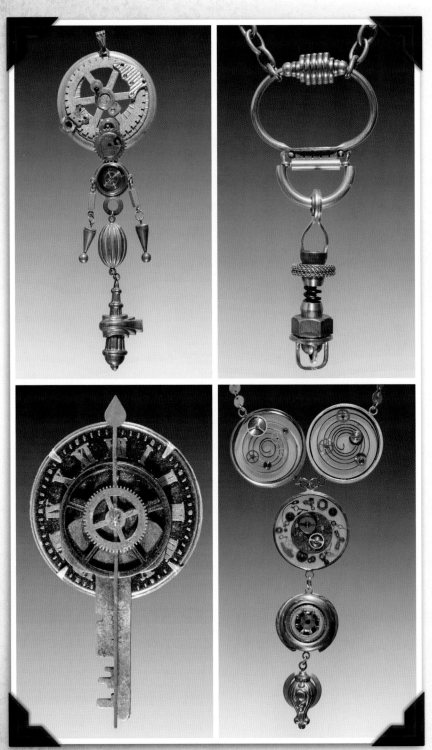

Left *Pendant*, 2012, 3" x 2" (7.5 x 5cm), vintage brass elements, base metal, vintage watch part. Collection of the artist.

Below *"Time Traveler" hinged cuff bracelet*, 2012, 7½" (19cm) circumference, 1½" (4cm) tall, 2½" (6.5cm) diameter, vintage corrugated copper, vintage brass elements, watch face, watch parts, resin. Private collection.

Beautifully rendered art jewelry pieces—which are actually more akin to miniature sculptures. Ann has a great graphic sensibility and a rare sophistication in coloration and details. She is one of the best Steampunk jewelry designers working today.

—ART DONOVAN

41

Anna Dabrowska

Anna Dabrowska, also known as Finnabair (pronounced Finavar), is from Warsaw, Poland. She is a woman of many interests: a mixed media artist, scrapbooker, art journalist, and teacher who loves new challenges, experimenting, and developing new techniques and skills. She's been creating since 2007, started scrapbooking in 2008–2009, and began working with mixed-media in 2009, when she became totally addicted.

Her projects are mostly media-based; she creates paper and canvas layouts, collages, and altered art, tags, journal pages, and much more. She loves texture and flea markets and believes in the power of recycling and upcycling.

She teaches her own mixed-media classes all around the world and creates as a freelance designer for scrapbooking magazines and international shops and as a product designer for well-known manufacturers.

Learn more by visiting *www.finnabair. com, www.flickr.com/photos/finnabair*, or by visiting the Finnabair Facebook page.

Midsummer Night's Dream, 2012, 19½" x 27½" (50 x 70cm), acrylic paint, gel medium, inks and pigments on stretched canvas, flea market findings, paper and fabric flowers, scrapbooking embellishments, self portrait photo.

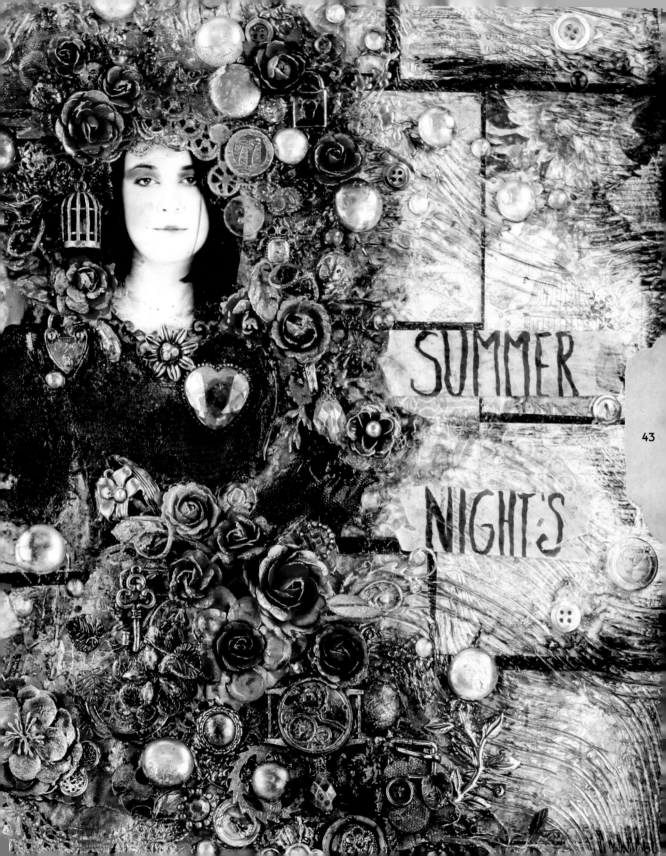

SUMMER

NIGHT'S

Inviting the Wind, 2012, 19½" x 27½"
(50 x 70cm), acrylic paint, gesso, gel
medium inks and pigments on stretched
canvas, flea market and computer
findings, natural string, fabric and paper
flowers, scrapbooking embellishments,
self portrait photo.

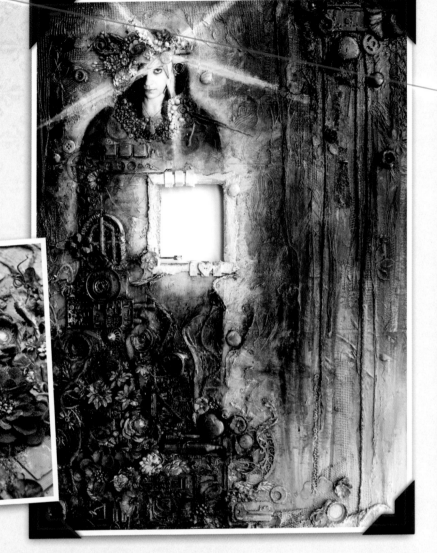

44

Paintings that are so richly encrusted with things like physical computer parts and machine parts that they could qualify as low relief sculptures. Anna's pallet is rich, sublime, and restrained and the surfaces glimmer like jewels—layer upon layer of imagery and texture, both painted and three-dimensional. She creates a mysterious and engaging surface that begs for close inspection.

—ART DONOVAN

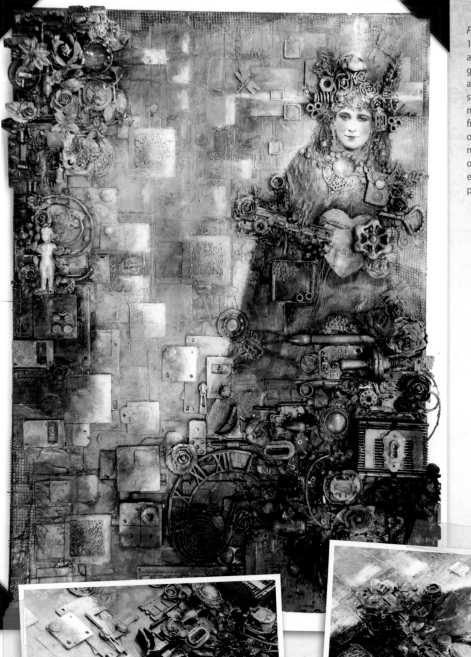

Fragmentation, 2012, 19½" x 27½" (50 x 70cm), acrylic paint, gesso, gel medium, inks and pigments on stretched canvas, flea market and computer findings (including old floppy discs), metal embellishments, other scrapbooking embellishments, self portrait photo.

45

Camryn Forrest

Camryn Forrest has lived most of her life in Colorado. She studied journalism and fine arts at the University of Colorado at Boulder.

A lifelong fascination with snow globes and small items led me to create tiny sculptures using found and repurposed items. To push the boundaries of the traditional snow globe from decoration and souvenir into a modern art form, I add different metallic glitters and reflective dusts in the liquid. When shaken, the shimmering result adds to the mystery, industrial fantasy, and storytelling in each design.

The contradiction that is Steampunk is based on "a future that never was, but might have been." For me, it is a diversion from the technology I do not understand, from thumb drives to remote controls. By contrast, the machinery of the industrial age comprised simpler components—gears, levers, pulleys, and chains—and was powered by simpler methods, such as human movement, gravity, and steam. These things I understand, and they are the language of my Steampunk art: A snow globe uses the simplest law of physics, gravity, to create a personal, emotional connection.

The influence of the Steampunk movement laces my artwork with the presence of such clear icons as airships and rayguns and models of tiny Tesla coils. The rich textures of wood, leather, metal, and glass become the backdrop to the visual humor and optimism, both a nod to history and a wink toward the future.

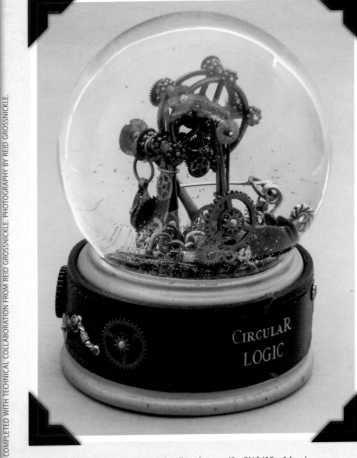

Circular Logic, 2012, 2½" (6.5cm)-tall sculpture, 4" x 5½" (10 x 14cm) exterior, glass globe, toy parts, clock gears, polymer clay support, leather, three-dimensional metal detailing, engraved brass plate. *Circular Logic* spins round and round, but always begins and ends in the same place. The conclusion is the same as the premise. The shape evokes the whimsy of a Ferris wheel, while the dark metal colors imply serious work is being contemplated. When shaken, this waterglobe fills with sooty metallic dust, reminiscent of coal-powered machines in the steam era.

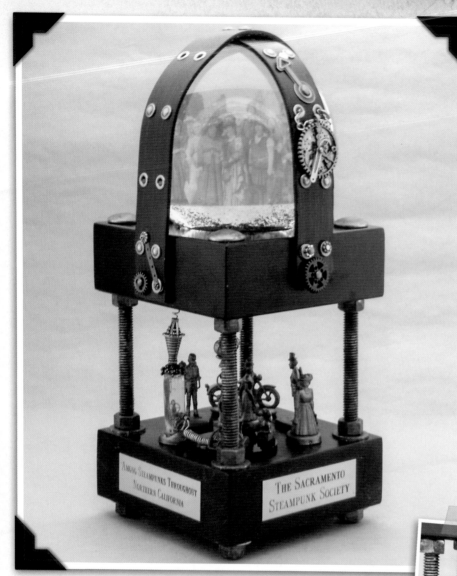

Sacramento Steampunk Society Display Globe, 2012, 4" x 11½" (10 x 29cm), glass globe, sepia-toned photograph, steampunk sculptures, engraved brass plates. This piece was made for the Sacramento Steampunk Society for a Steampunk event. My first thought was that snow globes are not big enough to make an impact from a distance, and my immediate second thought was, why not? Creating a two-level sculpture, both interior and exterior, gave new impact to the snow globe and blurred the line between inside and out.

I used leather strapping with hardware and metal detailing to secure the glass globe. The bottom level contains sculptures of individuals with steampunk items, including a jetpack, ray guns, vintage motorcycle, and a traveling chair.

47

C amryn's delightful globes feature tiny Steampunk dreams and fantasies, the miniature steampunk icons frozen in time. All rendered with a rare honesty that is at once precious, but upon closer inspection, speaks of a richer and slightly darker vision.

—ART DONOVAN

Top *Rain Gear*, 2012, 2¾" (7cm)-tall sculpture, 4" x 5½" (10 x 14cm) exterior, glass globe, repurposed jewelry, assorted watch gears. The sculpture that became *Rain Gear* evolved on its own, allowing the materials to dictate the design. The first stage was noticing how the circular shapes in handmade lace could mimic an assortment of scattered watch gears; then, seeing a lace parasol and envisioning gears instead of fabric. The tiny umbrella shade was finished long before a happenstance group of jewelry findings suggested jaunty robotic legs were more fitting than the expected curved umbrella handle. While many automatons and robots strive for serious, important work, this is a machine whose entire purpose is to stomp puddles.

Bottom *Indecision*, 2012, 2¾" (7cm)-tall sculpture, 4" x 5½" (10 x 14cm) exterior, glass globe, metal, wire, miniature figures, stamped copper words, engraved brass plate. *Indecision* is the delicious and lazy moment between yes and no, yesterday and tomorrow. It features several tiny people who move slightly, tentatively, but never commit anywhere. Two men sit high above the world on a teeter-totter, but only shift a fraction up and down. Another figure is trapped in a circle that rolls slightly left and right, but always returns to center. They sit on a structure that appears to have purpose, as all machines do, but are content to wait for something to happen, rather than taking the initiative.

48

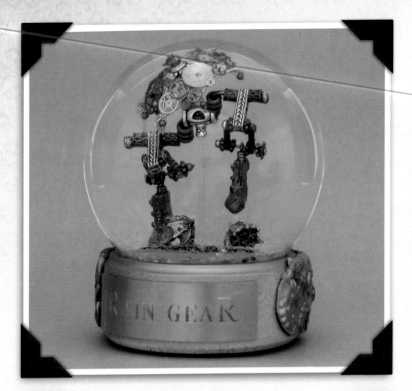

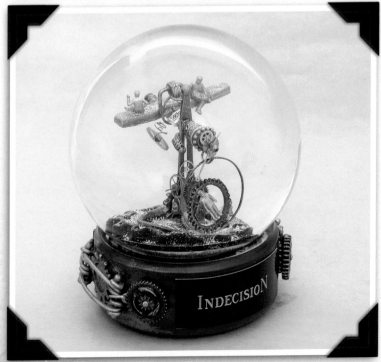

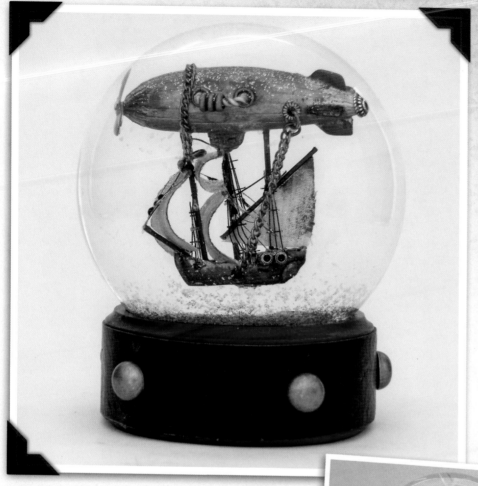

Left *Airship Voyager*, 2012, 2¾" (7cm)-tall sculpture, 4" x 5½" (10 x 14cm) exterior, glass globe, metal, leather. During the sculpting of *Airship Voyager*, weathering the exterior of the ship to suggest a long voyage and many adventures became the key to this fantasy piece. The worn and patched ship prompts the viewer to write the story about where the ship has been and where it is going. The tiny sailing ship below measures less than 1½" (4cm) from stem to stern, putting a twist on the traditional ship in a bottle.

Right *Ray Gun One*, 2012, 2¾" (7cm)-tall sculpture, 4" x 5¾" (10 x 14.5cm) exterior, glass globe, metal items, repurposed jewelry, sculpted clay, riveted leather strap, glass fuses. When shaken, the tiny "*Indiana Jones*" meets *The Jetsons*" ray gun is engulfed in a shimmering storm of silver flecks, suggesting energy and electricity. Wrapping the base in a belt with glass fuses was obvious; one cannot use a gun belt with bullets, as ray guns do not use bullets. However, fuses might come in handy. The copper discs along the interior base are individually molded from antique military buttons.

Evelyn Kriete

Evelyn Kriete is an editor, artist, fashion designer, blogger, marketing adviser, and stylist. She is an event producer with active involvement in a wide range of subcultures and trends, and is a moving force behind the steampunk trend worldwide. She has appeared in the *New York Times* and *San Francisco Chronicle*, as well as on MTV, VBS.tv, and NBC. She does programming for New York Comic Con and is the co-founder of Gilded Age Records. She has worked with projects such as the steampunk exhibition at the Museum of the History of Science in Oxford, Maker Faire New York, the films *Repo! The Genetic Opera* and *War of the Worlds: Goliath*, and the webseries *World of Steam*. She is the creative director and acquisitions editor for *Steampunk Tales*, an editor for Wildside Press, and has worked with *Weird Tales* magazine. She blogs for *ComicMix.com* and other blogs. Her writing has appeared in *Steampunk II: Steampunk Reloaded* and *The Steampunk Bible*.

She is the author of a forthcoming book on steampunk fashion and is a fashion designer for Gallery Serpentine. The art and fashion that Evelyn creates are things that she herself would admire or wear. Her own tastes drive her creative aesthetic.

50

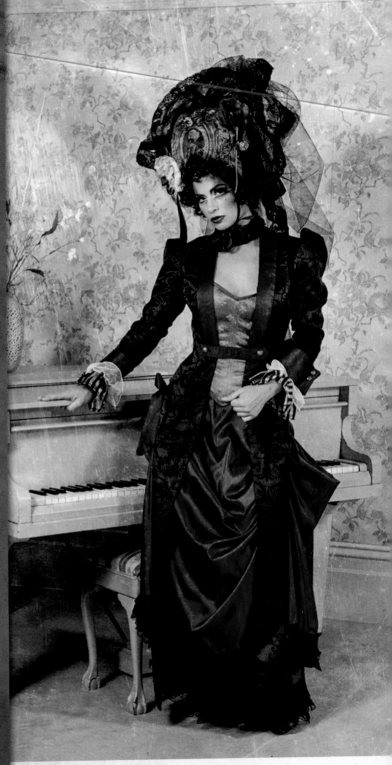

Fashion by Gallery Serpentine. Photography by Zelko Nedic.

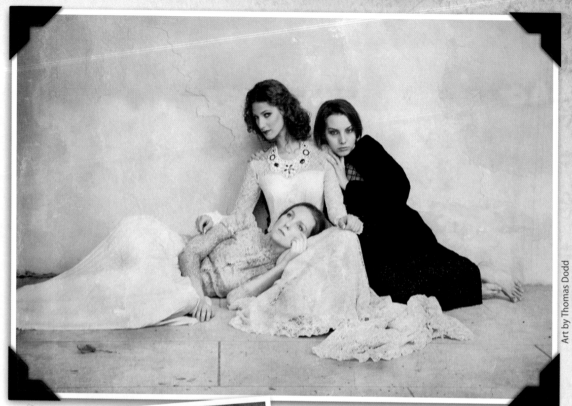

Art by Thomas Dodd

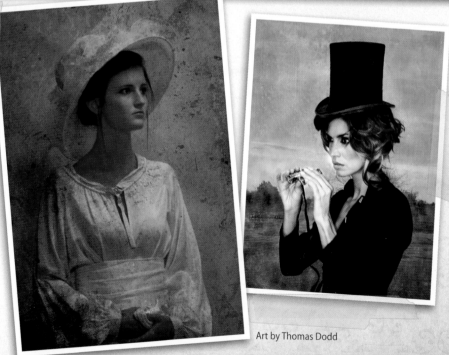

Art by Thomas Dodd

Filip Sawezuk

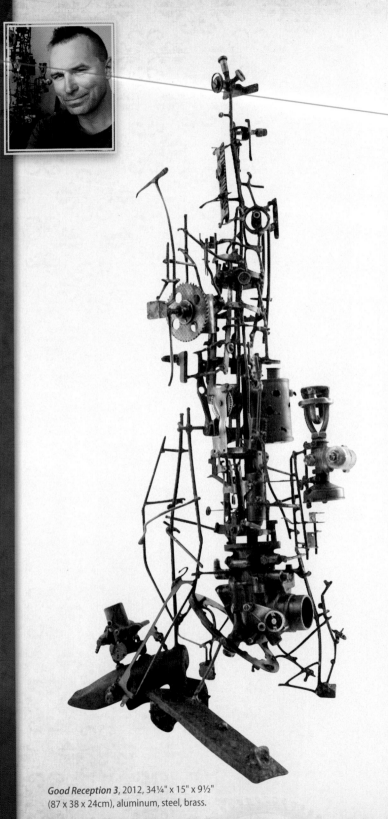

I arrived in Australia from Lodz, Poland, in 1986. I am a self-taught artist working as a house painter and construction worker. The inspiration to create art happened at work. During one of my jobs, I was sent to the Powerhouse Museum in Sydney. While I was there, all the vintage and antique pieces caught my attention, especially a piece of aluminum furniture made by Marc Newson, an Australian designer, called *Lockheed Lounge*. I fell in love with the piece straightaway; from that day, I wanted to create something.

Initially, I restored old vintage lamps, which led me to designing and building my own lamps out of found parts. During the past three years I started making abstract futuristic sculptures. Since I was a young kid, I've been fascinated by UFOs and science fiction movies. These interests have influenced my sculptures, giving them a futuristic, Steampunk-style appearance.

I use an arc welder to put together all my pieces. I try to pay special attention to the careful process of fabricating the metal parts. At the same time, I try to make the sculptures look very futuristic and abstract while blending in old vintage parts.

My sculptures are made of found metal parts that are purpose bought, e.g., vintage car parts, typewriter parts, and sewing machine parts. I source them from a variety of places from junk shops to car yards. When I am looking for parts for my art, if something catches my eyes I need to have that piece, even if I don't know what I will be creating with it at that time. I picture in my mind the potential of these inanimate objects that is way beyond their original purpose.

52

Good Reception 3, 2012, 34¼" x 15" x 9½" (87 x 38 x 24cm), aluminum, steel, brass.

Filip's strength lies in his artistic restraint and his laudable resistance to include capricious elements, as he never deviates from the "device" itself. His sculptures are wonderfully kinetic physical sketches—cohesive and dramatically graphic. They allude to actual Steampunk devices that were either never completed, or in the state of severe decay after many centuries (like the Antikythera Mechanism).

—ART DONOVAN

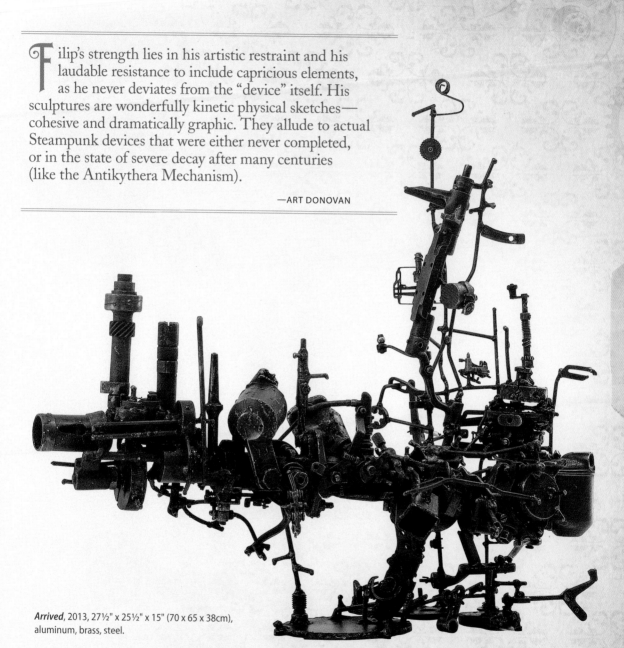

Arrived, 2013, 27½" x 25½" x 15" (70 x 65 x 38cm), aluminum, brass, steel.

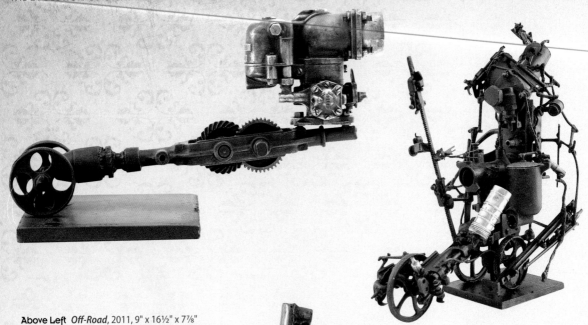

Above Left *Off-Road*, 2011, 9" x 16½" x 7⅞"
(23 x 42 x 20cm), aluminum, steel, brass.

Above Right *Upgraded*, 2012, 19¾"
x 15¾" x 7⅛" (50 x 40 x 18cm), steel,
brass, aluminum.

54

Middle *Wheeler*, 2011, 15½" x 11⅞" x 7½"
(39 x 30 x 19cm), steel, bronze, wood.

Below *Taken Off*, 2012, 20½" x 8¾" x 8¼"
(52 x 22 x 21cm), brass, aluminum, steel.

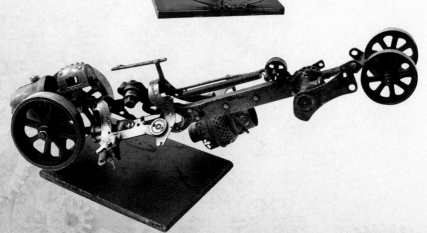

These re-imaginings are the epitome of creative abstraction and really stir the viewer's imagination as well. Afterwards, you might even find yourself inspired to create something yourself.

—GARETH BEAL, ARTSHUB

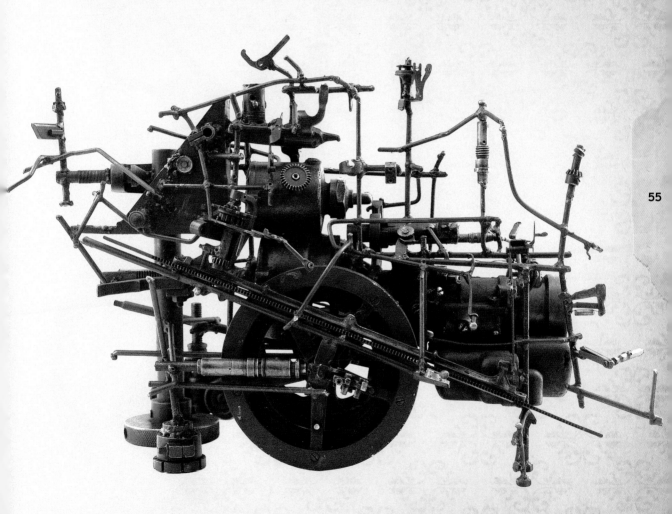

Booster, 2013, 21¾" x 14" x 9⅞" (55 x 35 x 25cm), steel, brass, aluminum.

Jessica Joslin

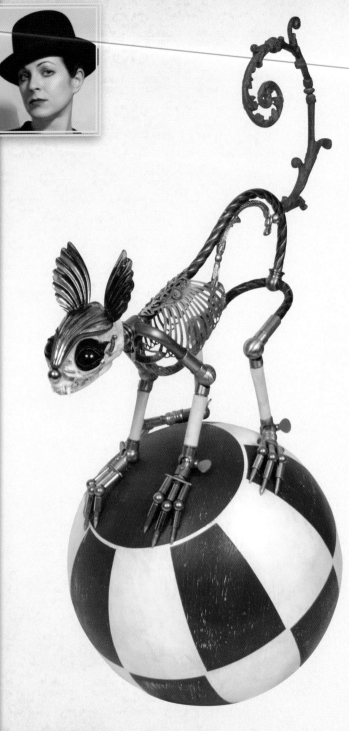

The creatures that populate Jessica Joslin's world are intricate fusions of bone, brass, antique hardware, and other scavenged treasures. Infused with the Victorian era's passion for natural history and arcane technology, these creatures reflect both the real and the imagined animal, the living and the dead. Through careful observation and intricate construction, they re-imagine the animal kingdom, bolt by bolt, beast by beast. They are a nod to the Wunderkammer of yore, and the Victorian predilection for invention and exploring science through the collecting of naturalia. The precision of the engineering conveys a sense that these beasts are anatomically plausible, and the spark of life is simulated through limpid glass eyes, engaging the viewer silently and directly.

Inspired by the beauty of skeletal architecture, and a passion for assemblage sculpture, Jessica Joslin began building her bestiary of mechanical animals in 1992. Her collection of creatures includes a myriad of species and hybrids, and numbers more than two hundred sculptures in total. With an extensive background in the professional trades, Joslin honed her fabrication skills building toy prototypes, architectural models, trade show displays, photo props, and film sets. Her monograph, "Strange Nature" was published in 2008, and her work has been featured in numerous books, magazines, and exhibitions worldwide. More work can be seen at *jessicajoslin.com*.

Hermes, 2012, 24" x 10" x 15" (61 x 25.5 x 40cm), antique hardware, chandelier parts, brass, bone, silver, painted steel, glove leather, glass eyes.

Jessica richly transcends the Steampunk category of Rogue Taxidermy to create exquisite art pieces, blending sculptural jewelry with the stunning visual architecture of her skeletal components. At first a bit scary, Jessica's artwork soon becomes endearing, and the wonderfully boney characters become actors in her story.

—ART DONOVAN

57

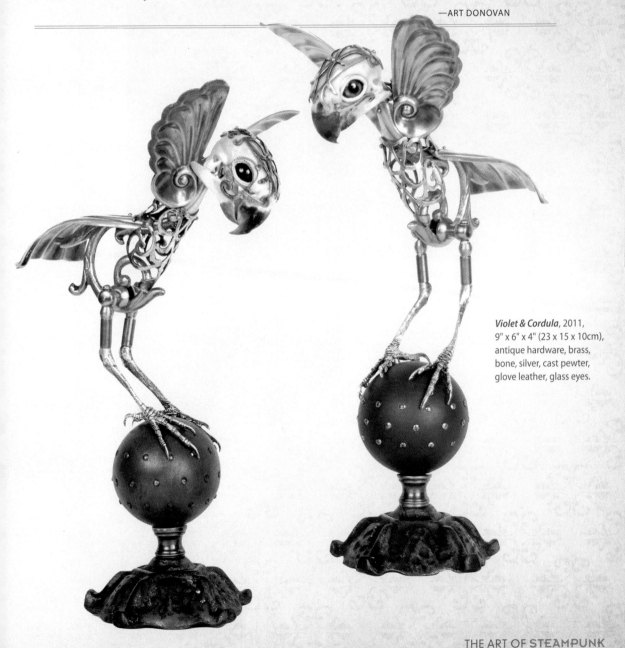

Violet & Cordula, 2011, 9" x 6" x 4" (23 x 15 x 10cm), antique hardware, brass, bone, silver, cast pewter, glove leather, glass eyes.

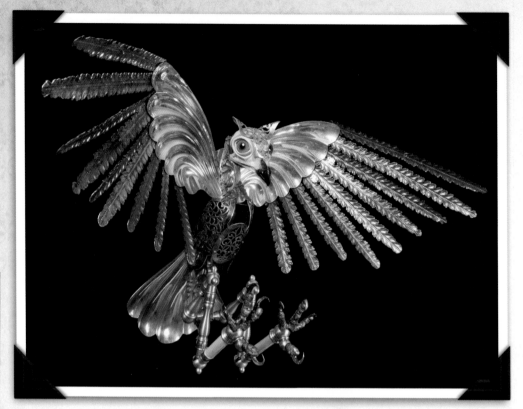

58

Above *Cooper*, 2011, 14" x 23" x 20" (35.5 x 58.5 x 51cm), antique hardware, chandelier parts, silver cutwork, brass, cast pewter, cast plastic, glove leather, glass eyes.

Right *Olive*, 2012, 3" x 2" x 7" (7.5 x 5 x 18cm), antique hardware and findings, brass, bone, wood finial, glove leather, glass eyes.

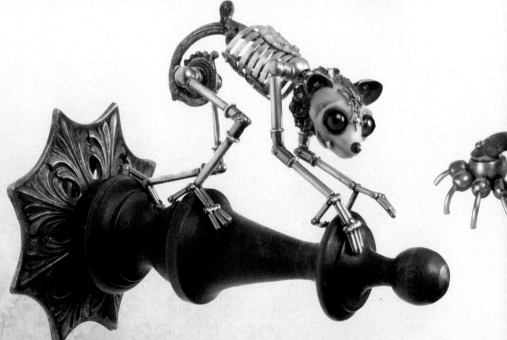

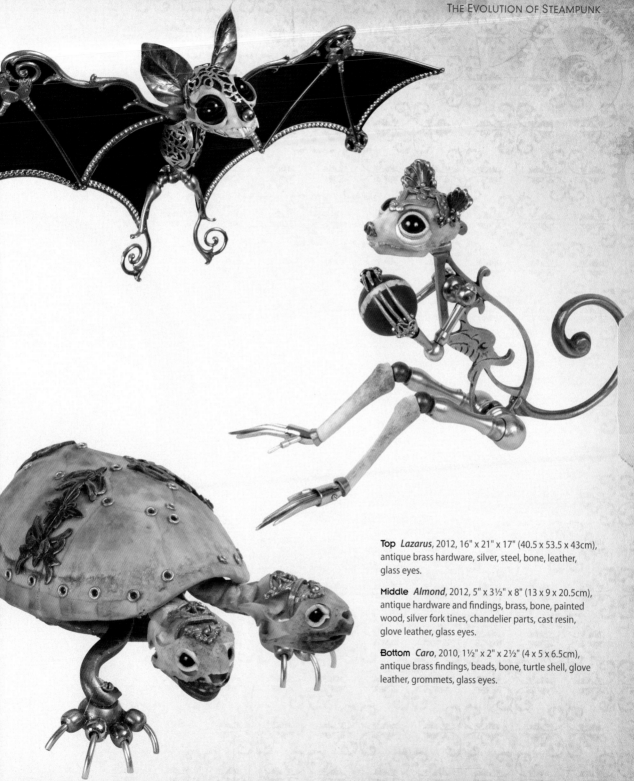

Top *Lazarus*, 2012, 16" x 21" x 17" (40.5 x 53.5 x 43cm), antique brass hardware, silver, steel, bone, leather, glass eyes.

Middle *Almond*, 2012, 5" x 3½" x 8" (13 x 9 x 20.5cm), antique hardware and findings, brass, bone, painted wood, silver fork tines, chandelier parts, cast resin, glove leather, glass eyes.

Bottom *Caro*, 2010, 1½" x 2" x 2½" (4 x 5 x 6.5cm), antique brass findings, beads, bone, turtle shell, glove leather, grommets, glass eyes.

Mikhail Smolyanov

PHOTO OF SMOLYANOV BY CYRIL KALAPOV FOR *MOTO EXPERT MAGAZINE*

Mikhail Smolyanov builds every one of his unique concept motorcycles from the idea to the details. Although his Steampunk bike designs are impressive, they make up only a small part of Smolyanov's work.

Smolyanov enjoys the design of old motorcycles and cars and applies this influence to his work. He is also inspired by dieselpunk, streamline, art deco, and classic European and American cars. His interest in Steampunk lies in the combination of demonstrative and fine mechanical structures—heavy black cast iron or steel parts and refined copper or brass mechanisms. He finds that many unexpected results can be gained from these combinations and implemented into practice.

Smolyanov uses 3ds Max software for the modeling and V-Ray rendering engine from Chaos Group for the rendering of his projects.

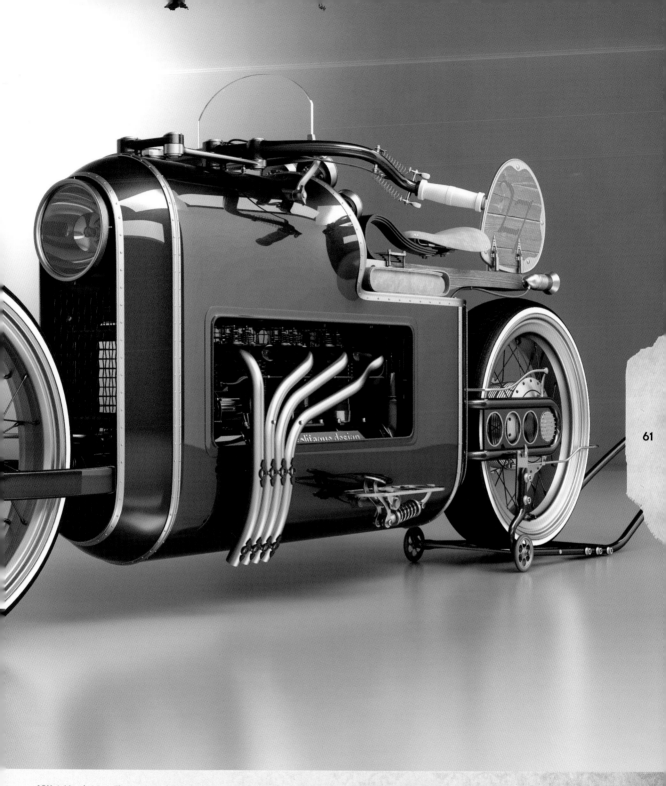

ARX-4, March 2011. The impetus for the creation of this work was the cars of the early twentieth century. Racing cars with airplane engines have some typical elements—the boat line-up, brass parts, spoked wheels, and wooden frame members. These elements result in a steampunk bike.

Top *GL-2m*, October 2011. This model and its predecessor, GL-1m, were created for Alexander Bushuev, *http://bushuev-motors.ru*. When developing the design, Smolyanov provided Bushuev with two options, one with a long tail and one with a short tail. He suggested using both versions to create two separate vehicles—GL-1m and GL-2m. The models were created with the active participation of Bushuev, who has since constructed a replica of GL-1m and has plans to do the same with GL-2m.

Middle *ARX-2*. This bike is part of Smolyanov's nose-over motorcycles series. The main feature is a simple body shape, but with a complex mechanism constructed around and within the body.

Bottom *Steampunk Chopper v.3*, sidecar edition, August 2011. This project is Smolyanov's version of the steampunk motorcycle used by Sherlock Holmes and Watson in the book *Steampunk Holmes* by Richard Monson-Haefel. The bike went through several rounds of design changes, resulting in this third version. Monson-Haefel intends to sell real samples, which will be built by Casey Putsch of Putsch Racing, *www.putshracing.com*.

62

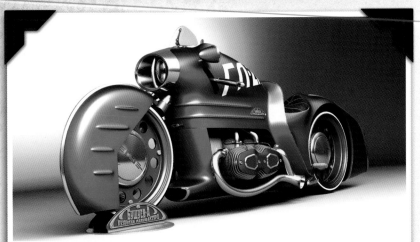

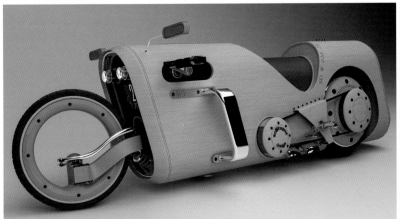

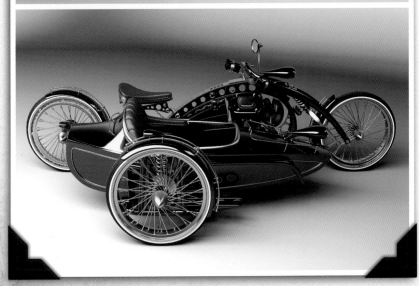

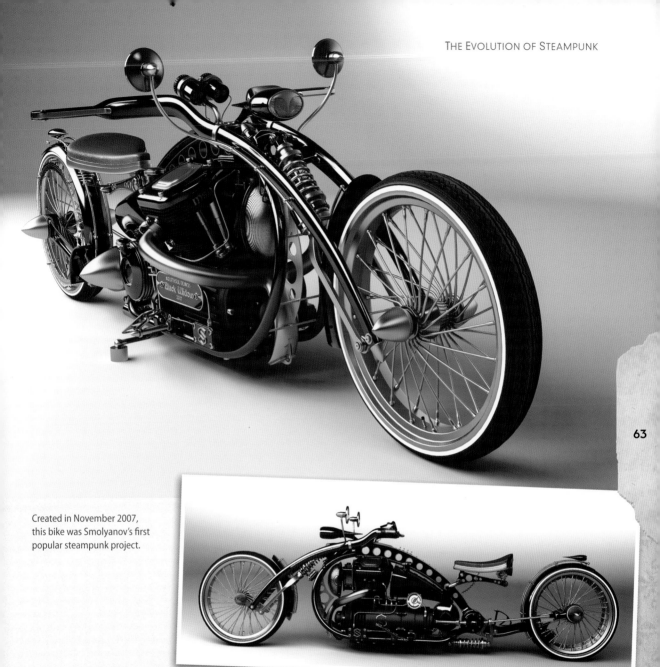

Created in November 2007, this bike was Smolyanov's first popular steampunk project.

I n my humble opinion, Mikhail is the greatest motorcycle designer I've ever seen. Breathtaking forms, proportions, and details with influences of Steampunk, Art Deco, and streamlined 1930s design. Elegance, originality and strength—on wheels!

—ART DONOVAN

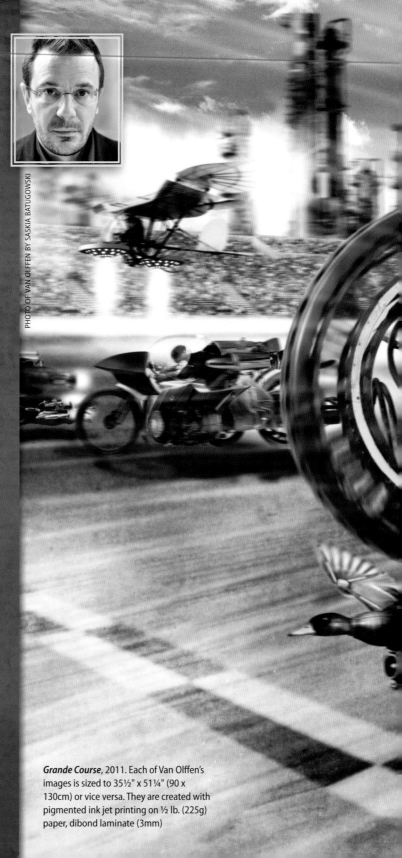

Sam Van Olffen

PHOTO OF VAN OLFFEN BY SASKIA BATUGOWSKI

Sam Van Olffen describes his illustrations as graphic sampling, because, just like a DJ of images, he extracts pictorial components out of their context in order to create his own visual melody. He invites you to enter his poetic, retro-futuristic trash universe. Van Olffen lives and works in Montpellier, a city in the South of France. He considers himself a tiny gear within the machine of the world. He likes thermonuclear bombs, web-footed birds, and cathedrals.

For Van Olffen, Steampunk art enables him to exercise his creativity. He says:

"Steampunk, and more generally Retro-futurism, is a genre that allows me and many artists to explore our creativity. Most often it deals with part retro/part vintage parallel universes, while being seen and apprehended through the prism of our century.

From that point the possibilities and perspectives become endless. For instance, what would our current time look like when adapted in the light of 2100? Because this is what it is all about. When Albert Robida imagined the future, he saw it through the fashion and architecture of its time. Now, we are revisiting the past using the technology and mindset of our times. It is a fascinating interplay of which Steampunk is, in a way, only one of many junctions, and these junctions, whether between the nineteenth and the eleventh century or the eleventh century with the eighteenth century, among many others, are interesting to develop."

Grande Course, 2011. Each of Van Olffen's images is sized to 35½" x 51¼" (90 x 130cm) or vice versa. They are created with pigmented ink jet printing on ½ lb. (225g) paper, dibond laminate (3mm)

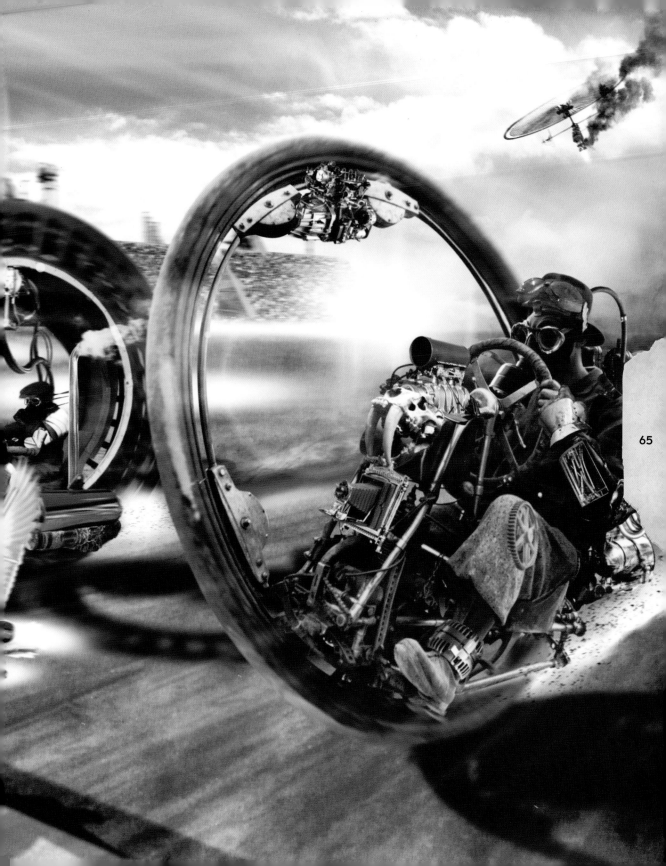

65

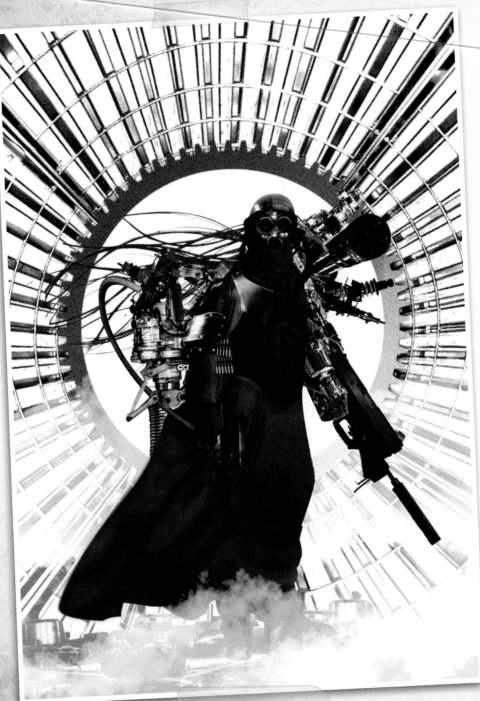

Sentinelle, 2008.

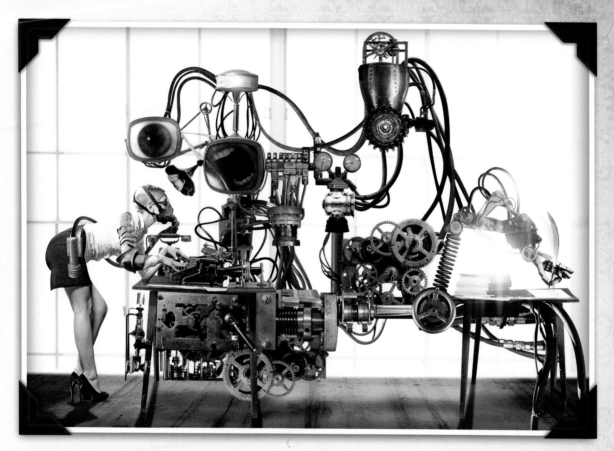

Secretaire, 2012.

S am brings a contemporary liveliness to Steampunk art, as he always includes surprising and sometimes humorous elements in his work. Dramatic, sophisticated, and sometimes wonderfully dark, Sam delivers that true French couture attitude—modernism integrated with infernal, antique machinations. His work is fully infused with French history, culture, and architecture.

—ART DONOVAN

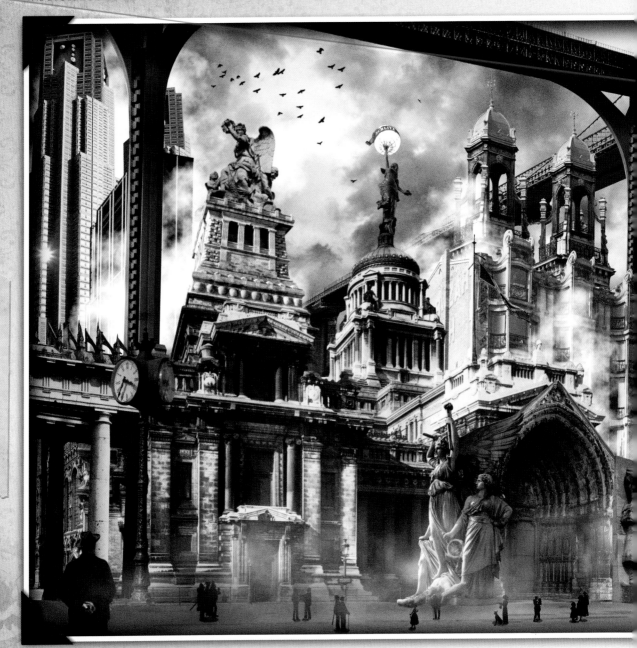

Ville Cathédrale IV, 2012.

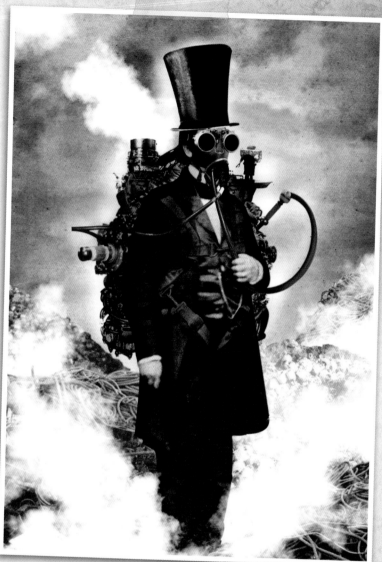

Chapelier, 2008.

69

STEAMPUNK 101

By G. D. Falksen

What is Steampunk?

In three short words, Steampunk is Victorian science fiction. Here, "Victorian" is not meant to indicate a specific culture, but rather references a time period and an aesthetic: the industrialized nineteenth century. Historically, this period saw the development of many key aspects of the modern world—mechanized manufacturing, extensive urbanization, telecommunication, office life, and

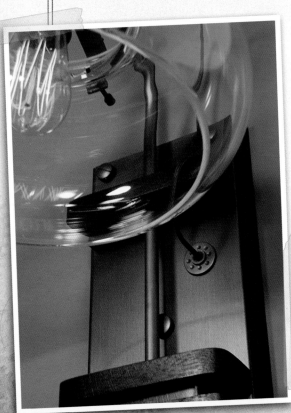

mass transit. Steampunk uses this existing technology and structure to imagine an even more advanced nineteenth century, often complete with Victorian-inspired wonders like steampowered aircraft and mechanical computers.

Where did Steampunk come from?

In some sense, Steampunk has existed since the nineteenth century. The Victorian period had its own science fiction, perhaps most famously embodied by the works of Jules Verne and H. G. Wells, and throughout the twentieth century, there have been science fiction stories set in the Victorian period. The term "Steampunk" was not coined until the late-1980s, however, when author K. W. Jeter used it humorously to describe a grouping of stories set in the Victorian period and written during a time when nearfuture cyberpunk was the prevailing form of science fiction.

Where does the Sci~Fi come in?

The line between Steampunk and period Victorian is extremely narrow, and often the two are indistinguishable. They are separated

only by Steampunk's status as science fiction, albeit heavily inspired by the historical facts of the Victorian period. This is generally accomplished in one of two ways. The "protoSteampunk" stories of the nineteenth century can be seen as a parallel to our own science fiction; that is, a view of the future from the present. For the Victorians, this meant imagining a future that looks dramatically unmodern to modern eyes. Submarines, space travel, aircraft, and mechanized life were all imagined by the Victorians, but while some of these came very close to the mark, they still differed from where the future actually went. For modern writers, with the benefit of modern science, Steampunk becomes a reimagining of the nineteenth century with a view of where science will one day go. In this way, Steampunk often works to translate modern concepts such as the computer revolution, spy thrillers, noir mysteries, and even the Internet into a Victorian context using Victorian technology. Steampunk becomes the perfect blending of alternate history and science fiction.

Where does steam come in?

Steampunk's steam references more than simply the technology itself, although steam engines are a vital aspect of life in a Steampunk world. Steam more generally signifies a world in which steam technology is both dominant

and prolific. During the Victorian era, steam power revolutionized almost every aspect of life. The steam engine made full-scale industrialization possible and produced mechanical power more efficiently and to greater degrees than human and animal labor could manage. Mechanized manufacturing and farming caused an upheaval in the structure of working life, but dramatically increased society's productivity and freed up an entire group of individuals to form the modern class of professionals and office workers. The changes in society brought on by steamdriven industrialization allowed for the unprecedented developments in science, society, and goods that came to be associated with the Victorian era. Steampunk takes inspiration from these changes and applies them to whatever culture it influences.

Where does the punk come in?

Ironically, it doesn't. As was mentioned earlier, the term Steampunk is a tongue-in-cheek reference to the cyberpunk genre rather than a reference to the punk subculture. Moreover, "punk," in the context of punk rock, was the product of very specific circumstances following the Second World War, which makes

Opposite *Oxford Station Lantern*, Art Donovan, 2010, 18" x 13" (455 mm x 330 mm), antique satin brass, mahogany, steel, hand-blown glass globe.
Above *Steampunk Tripod Floor Lamp*, Art Donovan, 2008, 60" (1524 mm) tall, solid mahogany, pine, brass, acrylic, glass.

71

The Artists
OF THE OXFORD EXHIBITION

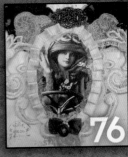

AMANDA SCRIVENER
London, United Kingdom
76

84

THOMAS WILLEFORD
Harrisburg, Pennsylvania,
United States

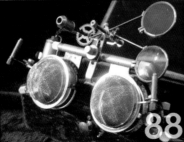

88

CLIFF OVERTON
Bundoora, Victoria, Australia

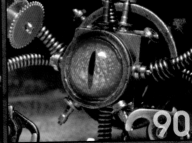

90

DANIEL PROULX
Montreal, Quebec, Canada

98

ERIC FREITAS
Royal Oak, Michigan,
United States

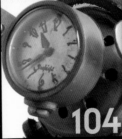

104

HARUO SUEKICHI
Tokyo, Japan

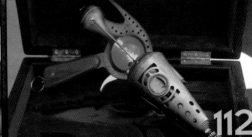

112

IAN CRICHTON
Woking, Surrey, United Kingdom

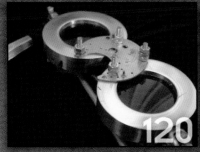 **120**

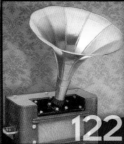 **122**

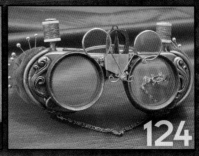 **124**

JAMES RICHARDSON~BROWN
Southampton, Hampshire,
United Kingdom

JESSE NEWHOUSE
New York, New York,
United States

JOEY MARSOCCI
Hartford, Connecticut,
United States

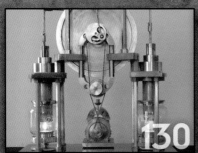 **130**

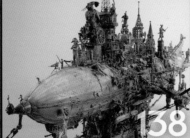 **138**

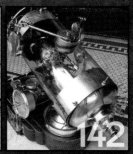 **142**

JOS DE VINK
Bovensmilde, Netherlands

KRIS KUKSI
Hays, Kansas, United States

MOLLY FRIEDRICH
Seattle, Washington,
United States

 144

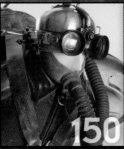 **150**

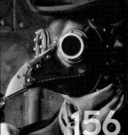 **156**

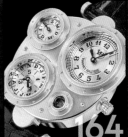 **164**

RICHARD NAGY
Chino, California,
United States

STEPHANE HALLEUX
Mohiville, Belgium

TOM BANWELL
Penn Valley, California,
United States

VIANNEY HALTER
Sainte-Croix, Switzerland

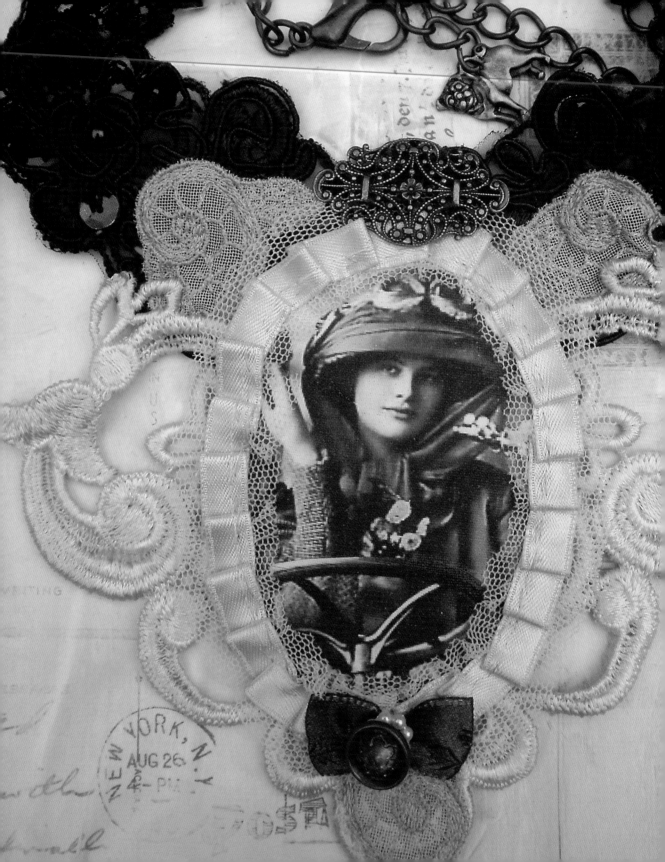

Amanda Scrivener

PROFESSOR ISADORA MAELSTROMME
London, United Kingdom

Photo by Martin Small

Opposite *Early Era Lady Automobile Driver Lace Choker*, 2010, lace, chains, photograph.

Amanda Scrivener is a well-known designer of wearable pieces of art whose work is clearly unique. After attending two art colleges to study textiles, jewelry design, and jewelry production, Mme. Scrivener's work became inspired by the shadowy side of Victorian England. As her creator persona Professor Maelstromme, she crafts items in her laboratory that will bring to mind romance by gaslight, arcane science, the steam age, carnival sideshow curios, and aged materials from the vaults of the Victorian past. She loves working with pocket watches and wind-up clocks, often cannibalizing them for parts. Mme. Scrivener's creations (sometimes designed in collaboration with Thomas Willeford) have been hailed as imaginative oddities that masterfully epitomize the diverse landscape of Steampunk design.

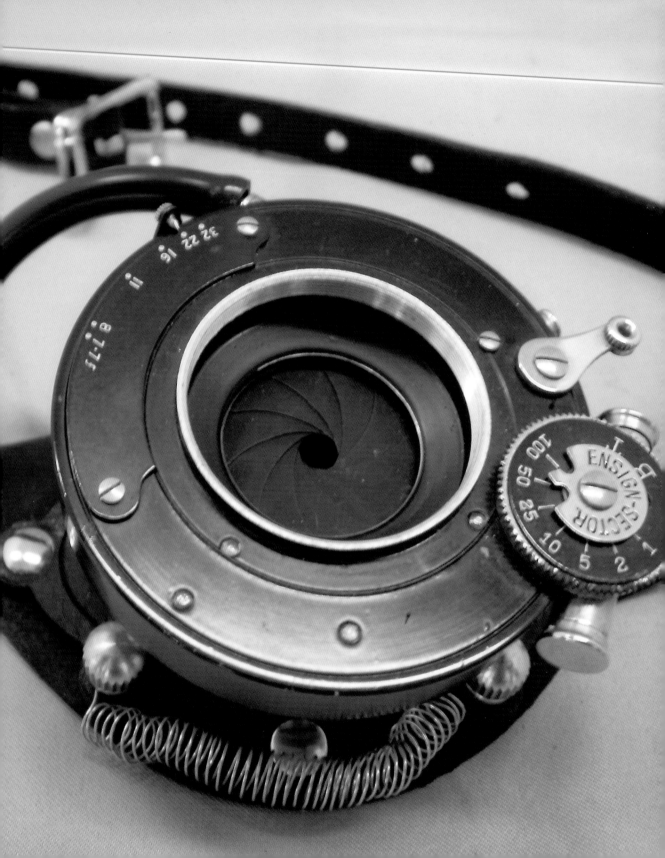

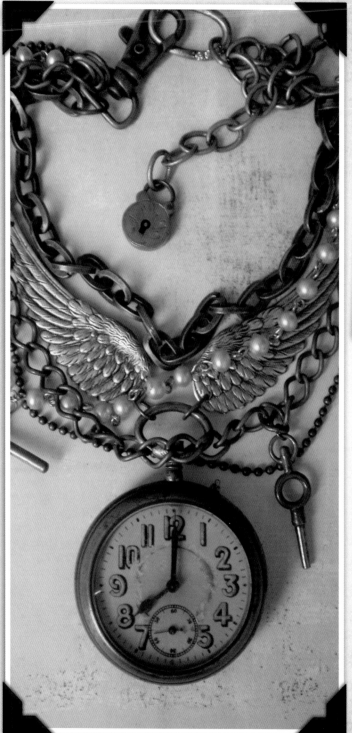

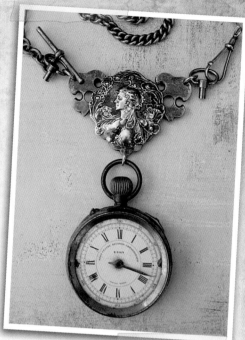

Opposite *Old Camera Lens Monocle*, black and burgundy leather, camera lens.

Left *Watch Chains Steampunk Inspired Necklace*, 2010, old pocket watch, old pocket watch chains.

Above *Old Pocket Watch Necklace*, 2009, pocket watch, pocket watch chains and clasps.

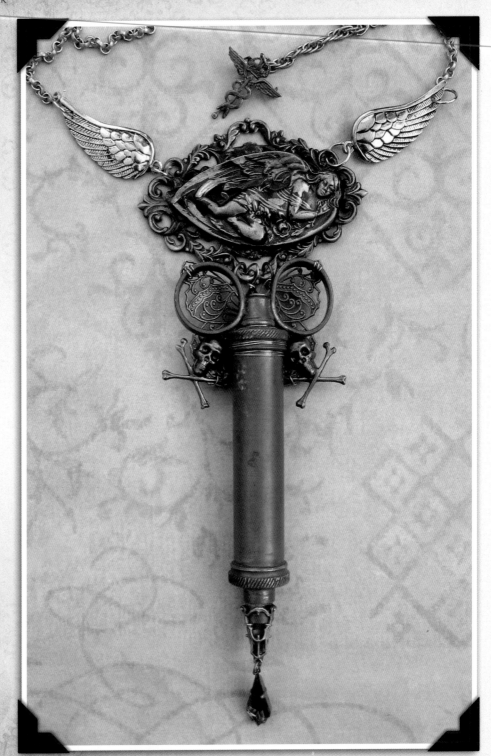

80

Right *Old Syringe Necklace*, 2009, brass syringe, chains.

Opposite *Winged Old Broken Pocket Watch Necklace*, 2009, broken pocket watch frame, silver ornament, chains.

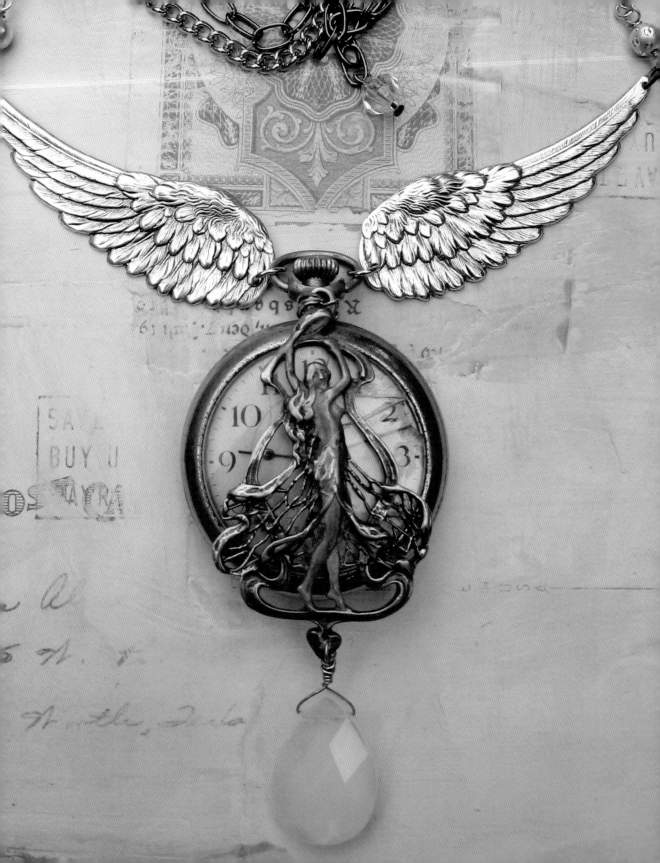

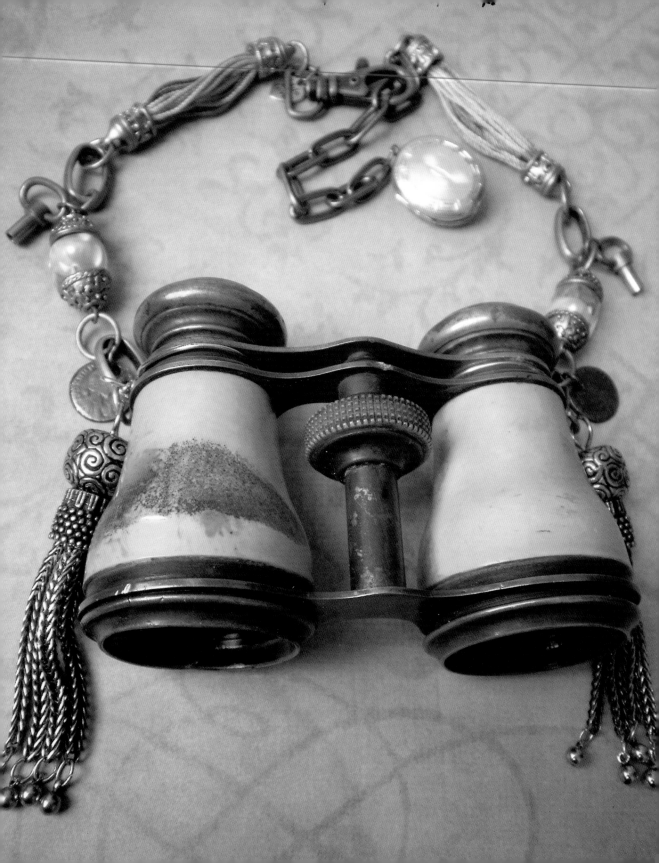

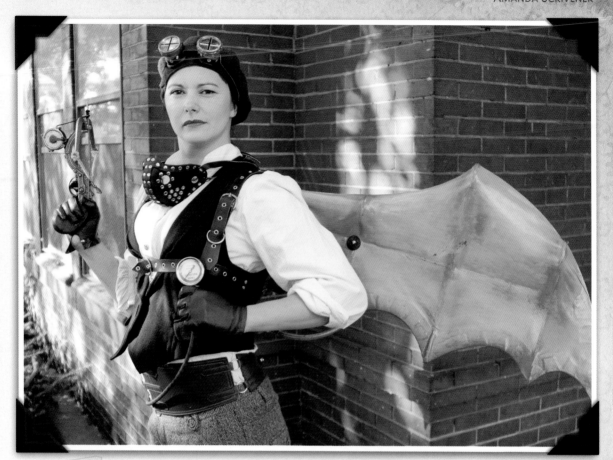

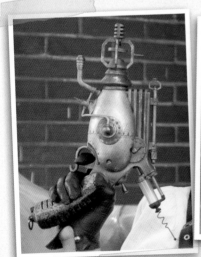

Opposite *Steampunk Adventurer's Club Necklace*, 2010, old binoculars, bolts, chains.

This Page *Steam Ornithopter*, *Leather Gas Mask*, and *Clockwork Arm Replacement Arm Mark II*, brass tubing, sheet brass, chrome sheet, various fittings, kydex, leather, found objects. Worn by Scrivener, these pieces were created in collaboration with Thomas Willeford. The raygun was made by Weta Workshops, New Zealand.

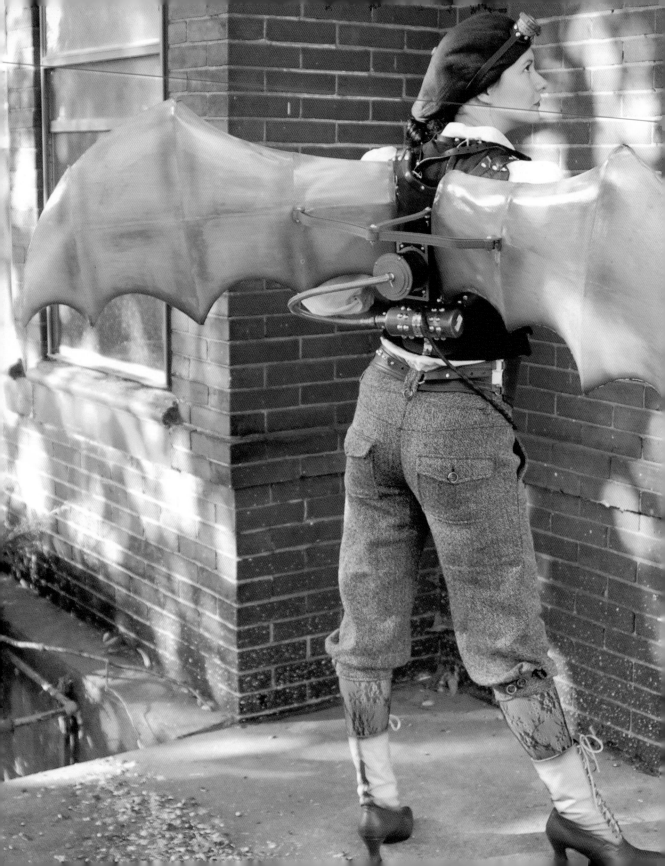

Thomas Willeford

LORD ARCHIBALD
"FEATHERS" FEATHERSTONE
Harrisburg, Pennsylvania, United States

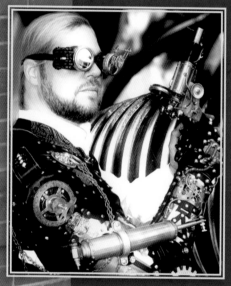

With degrees in physics, history, and art, it was perhaps inevitable that Thomas Willeford would be a Steampunk enthusiast. His work attempts to blur the precarious line between art and engineering. If upon viewing a piece one does not ask, "Does that actually work?" then Willeford considers the piece a failure.

Sculpture and wearable art are Willeford's preferred art forms because he cannot draw or paint very well. Willeford's alter ego, Lord Archibald "Feathers" Featherstone has been exhibiting his work throughout the United States and Europe for years. He hopes to continue to support the cause of mad scientists everywhere for many more years to come.

Opposite Shown here is the *Steam Ornithopter*, designed and created by Thomas Willeford and Amanda Scrivener, and worn by Scrivener.

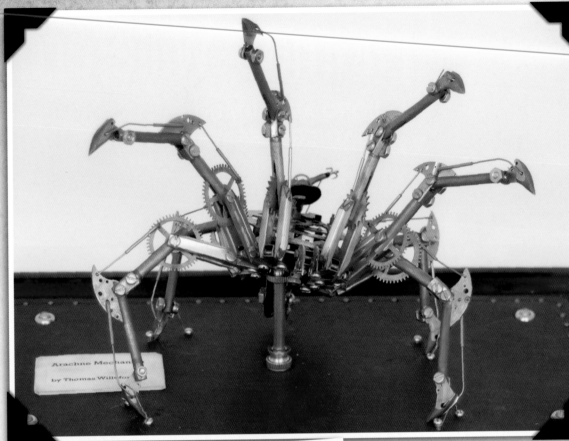

86

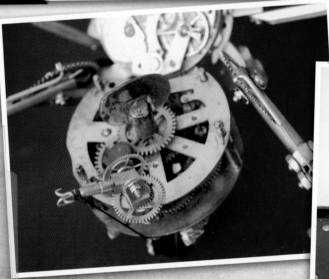

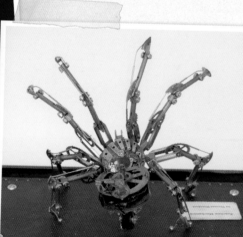

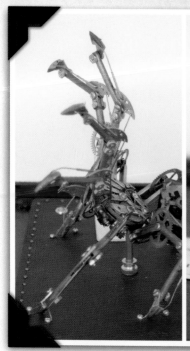
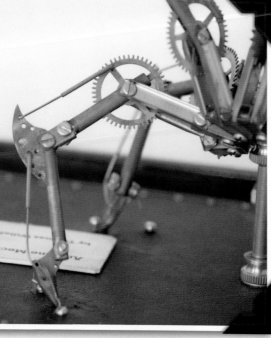

Opposite *Arachnia Mechanica*, brass. Thomas Willeford's brass spider is a fully articulated stop-motion animation model.

This Page Several angles of Willeford's *Arachnia Mechanica* show the details of its construction and movement.

Below This piece, on display at the Steampunk exhibition, was created by Thomas Willeford and Amanda Scrivener.

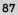

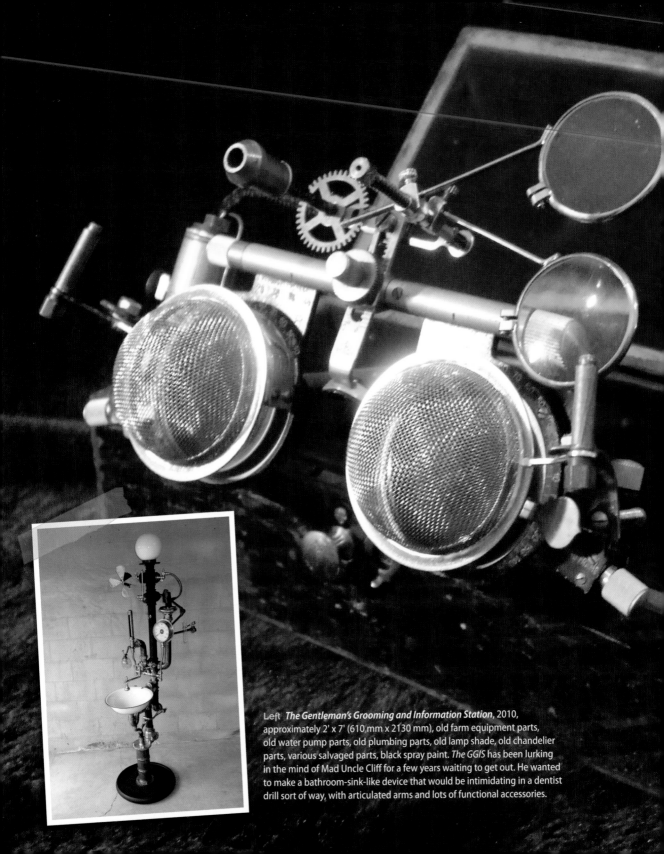

Left *The Gentleman's Grooming and Information Station*, 2010, approximately 2' x 7' (610 mm x 2130 mm), old farm equipment parts, old water pump parts, old plumbing parts, old lamp shade, old chandelier parts, various salvaged parts, black spray paint. *The GGIS* has been lurking in the mind of Mad Uncle Cliff for a few years waiting to get out. He wanted to make a bathroom-sink-like device that would be intimidating in a dentist drill sort of way, with articulated arms and lots of functional accessories.

Cliff Overton

MAD UNCLE CLIFF
Bundoora, Victoria, Australia

Opposite *The Inspectacles*, 2009, an old pair of phoropters, magnifying lenses, tea strainers, LED light, old brass bits, shoe lace, colored lenses. Overton considers *The Inspectacles* to be part of his "rite of passage" into Steampunk tinkering, as most tinkerers make a pair of goggles at some stage. *The Inspectacles* were inspired by Johnny Depp's character in the film *Sleepy Hollow*.

For Cliff Overton, Steampunk art is many things: it's a rebellion against the beige and plastic look, it's an attempt to subvert design culture, it's ornamentation for the sake of ornamentation, it's recycling and putting the fun back into modern products, and it's romanticism.

Overton begins any modification by looking at a modern product and trying to decide what it would look like if it were running on steam, and wheels and pistons were part of its operational design. There would be pressure gauges, valves, and switches. Overton takes these elements from the past and uses them to subvert the smooth shapeless panels of today's technology.

Creations by Overton, in his Steampunk persona Mad Uncle Cliff, rebel against his ten years of industrial design experience. He knows that a project is good if someone tells him no one else will ever want it. Overton then knows his creation is a success because he did not make it for someone else, he made it for himself.

Overton is a firm believer that a new market for robustness, reliability, and usability will soon come to the forefront of today's society—just the place for Steampunk art and design.

For more information about Overton and his designs, please visit his blog at *http://austeampunk.blogspot.com*, or email him at *cliffo@three.com.au*.

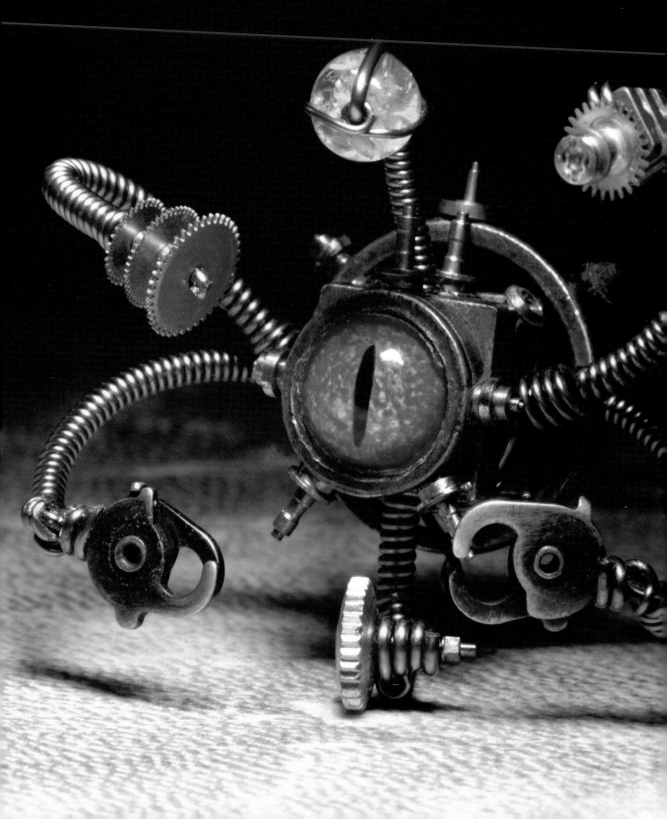

Daniel Proulx

Montreal, Quebec, Canada

Opposite *Beholder Robot Sculpture*, 2009, copper, clock parts, taxidermy glass eye, metal beads, findings.

Daniel Proulx was born in Montreal and spent a considerable amount of time traveling the world before returning to his artistic roots, becoming an independent artist in 2008. He has found great inspiration in the steam era and now makes Steampunk jewelry with metal wire, gemstones, vintage clock parts, and other unusual components. He loves creating organic shapes from wire and making intricate designs with a mechanical/industrial feel.

When Proulx was young, he used to daydream about fantastic imaginary worlds. He would draw monsters, invent stories about magical items, or role-play with friends. Now Proulx brings his art to life with stories from a distant parallel Steampunk universe. He uses his creations to share his passion for the world of Steampunk with the rest of us.

Sunday, October 13, 1809 • Quebec, Canada

The Montreal Science Journal

By Daniel Proulx

This morning, around three o'clock, a large explosion flattened three buildings in the heart of the industrial district. The explosion originated from the laboratory of a controversial scientist. No remains were found. The blast was so powerful that the scientist was instantly pulverized.

Although the cause of the explosion has not yet been confirmed, experts have reason to believe that it might be related to a mysterious device found in the center of the crater produced by the blast.

Earlier this year, the scientist failed, for the third time, to successfully demonstrate his so-called time machine at the Academy of Universal Scientific Wonders (AUSW). It would appear that this time his experiment went too far.

A few mysterious items were found among the ruins of the laboratory. They will be displayed at the local museum for a brief period of time before being sold to the highest bidder at an auction whose proceeds will benefit the AUSW.

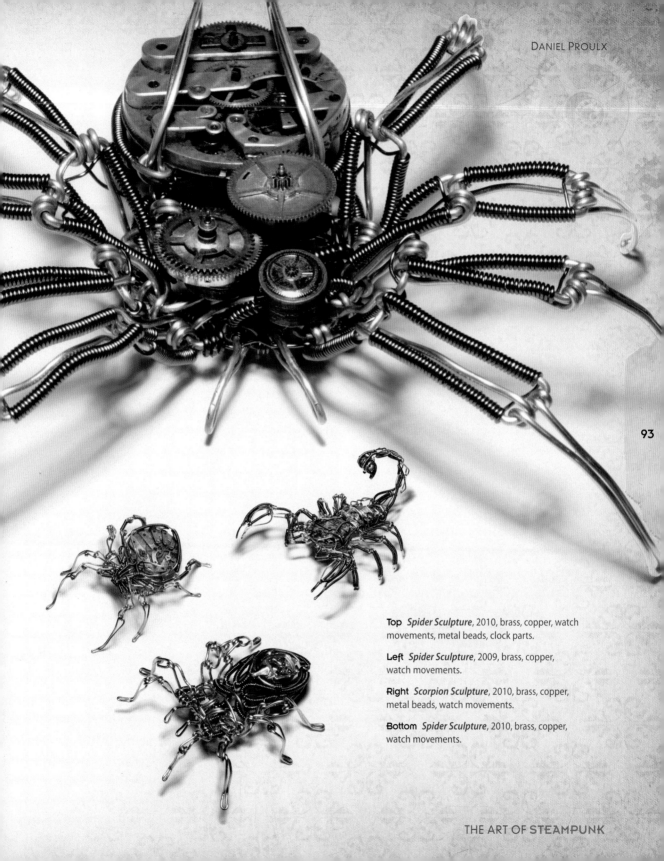

93

Top *Spider Sculpture*, 2010, brass, copper, watch movements, metal beads, clock parts.

Left *Spider Sculpture*, 2009, brass, copper, watch movements.

Right *Scorpion Sculpture*, 2010, brass, copper, metal beads, watch movements.

Bottom *Spider Sculpture*, 2010, brass, copper, watch movements.

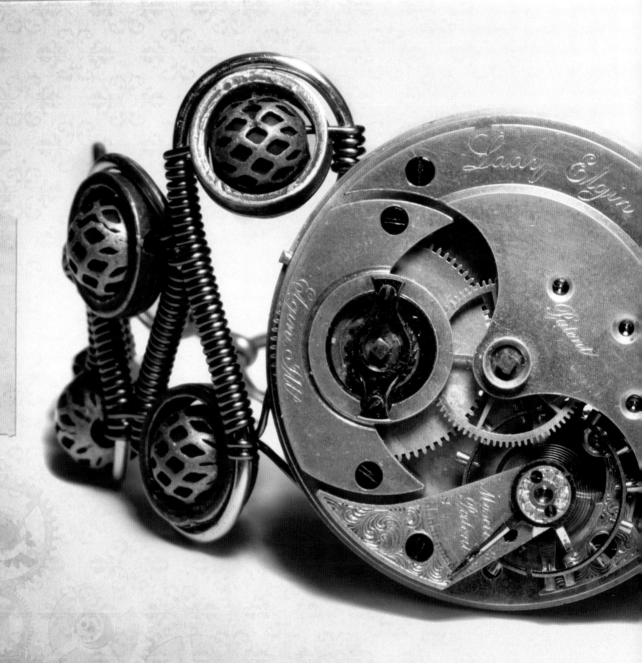

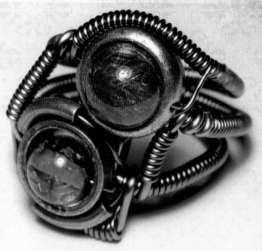

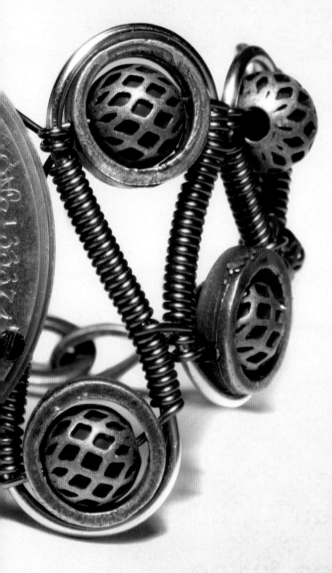

Opposite *Lady Elgin Brass Watch Movement Bracelet*, 2010, brass, metal beads, watch movements, findings.

Above *Green Amber and Copper Rutilated Quartz Ring*, 2010, copper, clock parts, amber, quartz, metal beads.

Right *Tie Tack With Reptile Eye*, 2010, clock parts, taxidermy glass eye, metal beads.

Below *Railroad Antique Brass Watch Movement Bracelet*, 2010, brass, copper, metal beads, watch movements, findings.

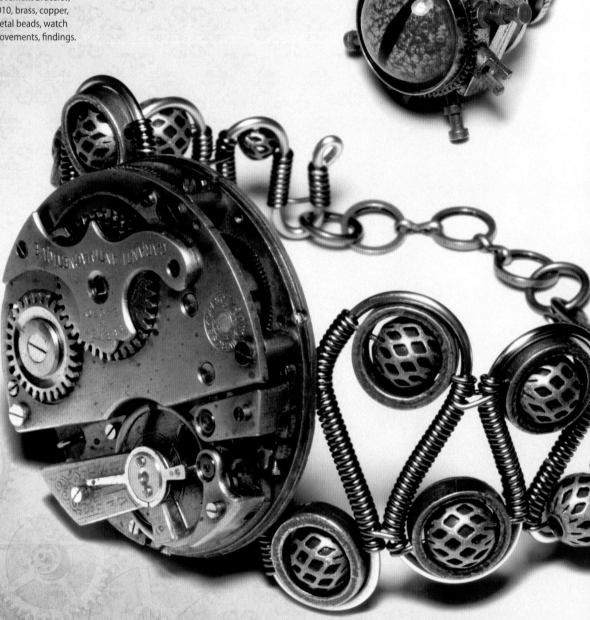

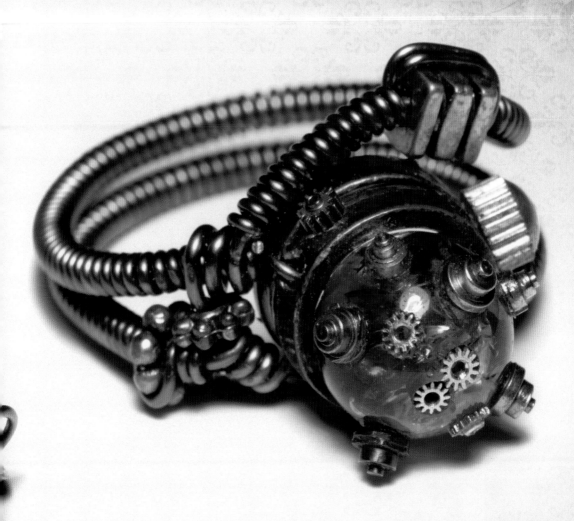

Above *Asymmetric Ring With Clock Parts Inlaid In Amber*, 2009, copper, clock parts, amber, metal beads.

Eric Freitas

Royal Oak, Michigan, United States

Opposite This photo shows the details of *Quartz 6*, a creation that was completed by Freitas in 2008.

Eric Freitas is a clockmaker with an art degree. He hand machines and sculpts every gear and chain link of his clocks to create his bizarre and beautiful timepieces. It's unlikely that many artists would tackle the kind of learning curve that clock-making presents, but Freitas is dedicated, driven, and very passionate about making his ideas become living ticking realities.

In 1999, Freitas graduated from the Center for Creative Studies with a major in graphic design and illustration. He never committed to the commercial world as planned and instead directed his attention to a far less common art form: clock making. Prior to this change in artistic direction, Freitas had never used machining tools. He studied from clock making and machining books for the sole purpose of executing his ideas.

With every project, Freitas tests the boundaries of horology to make way for a style never seen in this very traditional world. He never allows the mechanical parts to dictate what his finished projects will look like. The mechanical is always structured around the visual rather than the other way around. After countless hours of precise work, the immediacy and essence of Freitas' initial sketch is still prevalent when the finished work makes its first tick.

Freitas documents the progress of his clocks on his website, *ericfreitas.com*, including *No. 7*, Freitas' largest clock creation.

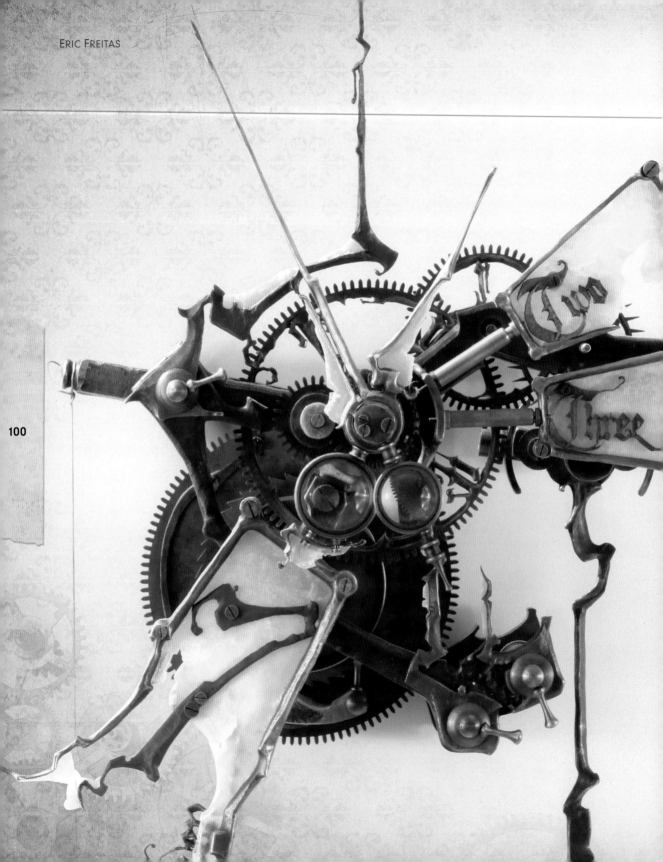

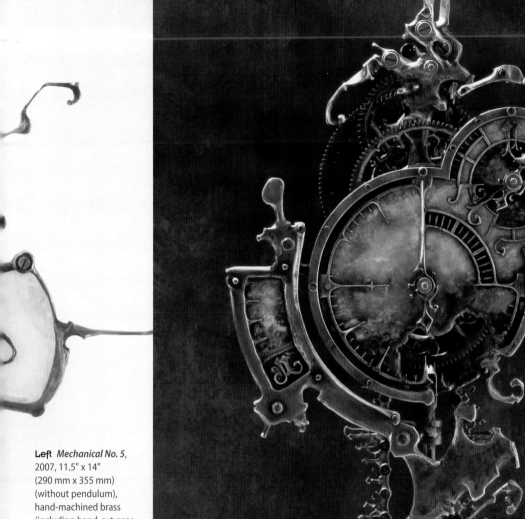

Left *Mechanical No. 5*, 2007, 11.5" x 14" (290 mm x 355 mm) (without pendulum), hand-machined brass (including hand-cut gear teeth and hand-threaded screws), kitikata rice paper, two lenses from a jeweler's loupe.

Right *Mechanical No. 6*, 2009, 7.5" x 22" (190 mm x 560 mm), hand-machined brass. For this piece, Freitas hand-cut more than 1,000 links to form the 10 foot chain and hand-threaded more than 100 screws.

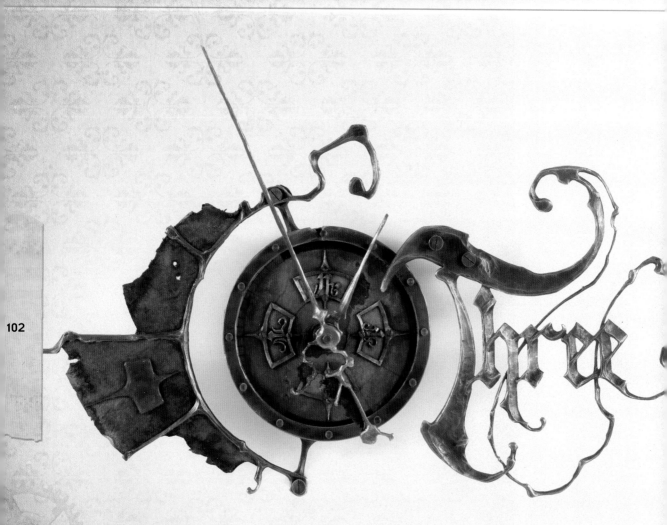

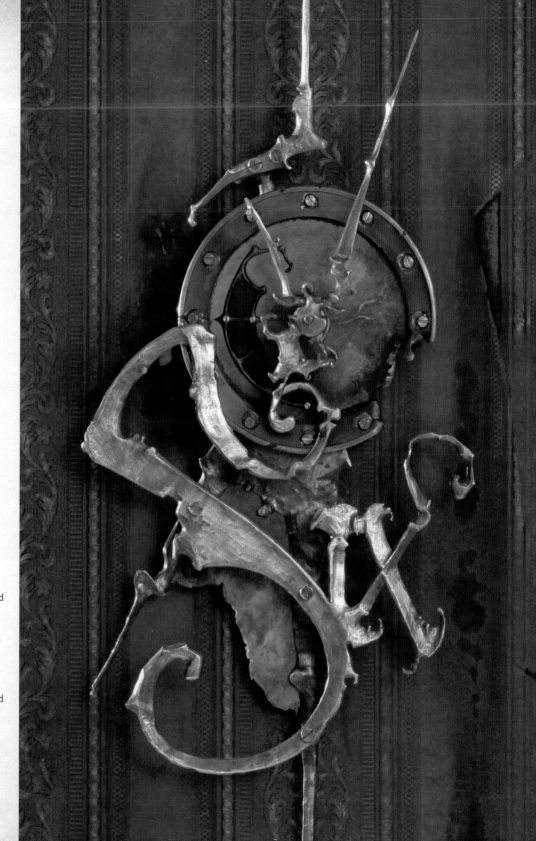

Left *Quartz 6*, 2008, 16.5" x 7" (420 mm x 180 mm), hand-machined brass held together with hand-threaded screws, with painted, weathered, and aged paper.

Right *Quartz 9,* 2009, 7" x 12" (180 mm x 305 mm), hand-machined brass held together by hand-threaded screws, with painted, weathered, and aged paper.

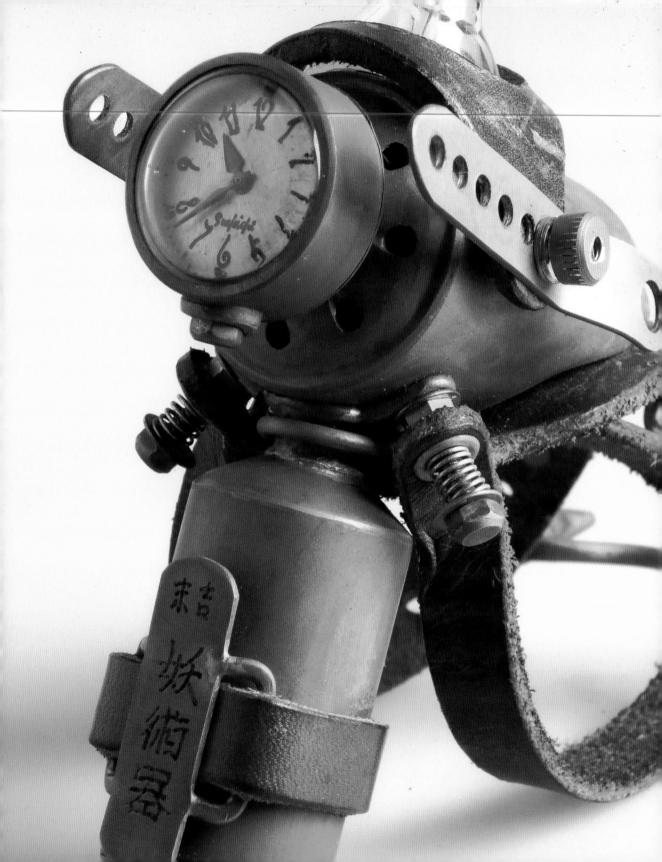

Haruo Suekichi

Tokyo, Japan

Photo by Ikumi Mochida

Opposite *Magical & Mystic Watch*, 2003, 4" x 4" x 2.5" (100 mm x 100 mm x 60 mm), brass, leather, springs. Wave your hand while wearing this watch, and it will make a fun sound.

Haruo Suekichi was born on May 15, 1970, and considers himself to be a regular guy who just happens to have a passionate "thing" for watches.

When Suekichi first started making watches in his mid-twenties, it was only as a hobby. At the age of twenty-four, he started selling his handmade watches on the street, in parks, and at small flea markets in Tokyo. He was soon discovered by a merchant from a small goods store who adored his watches. By the time he turned twenty-nine, Suekichi was using the merchant's shop cellar as his own workplace.

Although Suekichi did not advertise his work and only attended a few small exhibitions, the media soon began to notice him.

Over the next ten years, Suekichi, who had never studied art and who had only started making watches for fun, grew to become a world-renowned Steampunk watch creator.

Suekichi's watches have been featured in print magazines such as *Time*, *Chief*, *PingMag*, *Tech Crunch Magazine* (Japan), and *A Day* (Thailand). His work has also appeared on numerous art and design websites.

The Oxford Steampunk exhibition was the first time Suekichi displayed his watches for a large international audience.

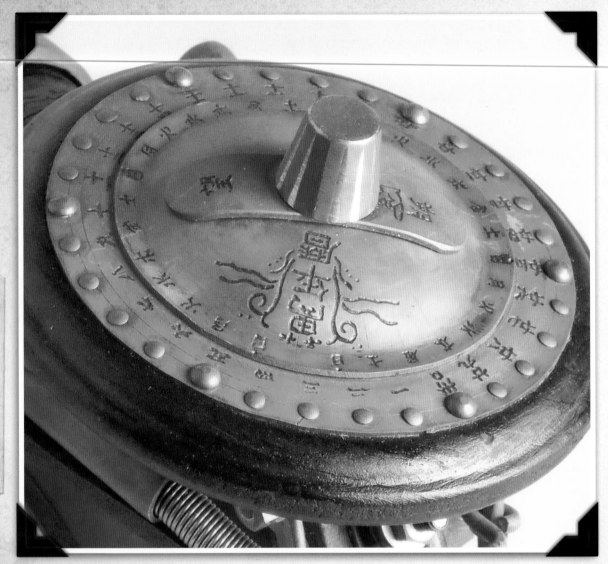

Lunar Period, 2007, 2.75" x 3" x 3.5" (70 mm x 80 mm
x 90 mm), brass, leather, wood. If you like astrology,
you'll love this piece. It tells you the stages of the
moon, which can help you make big decisions about
relationships, money, and your career.

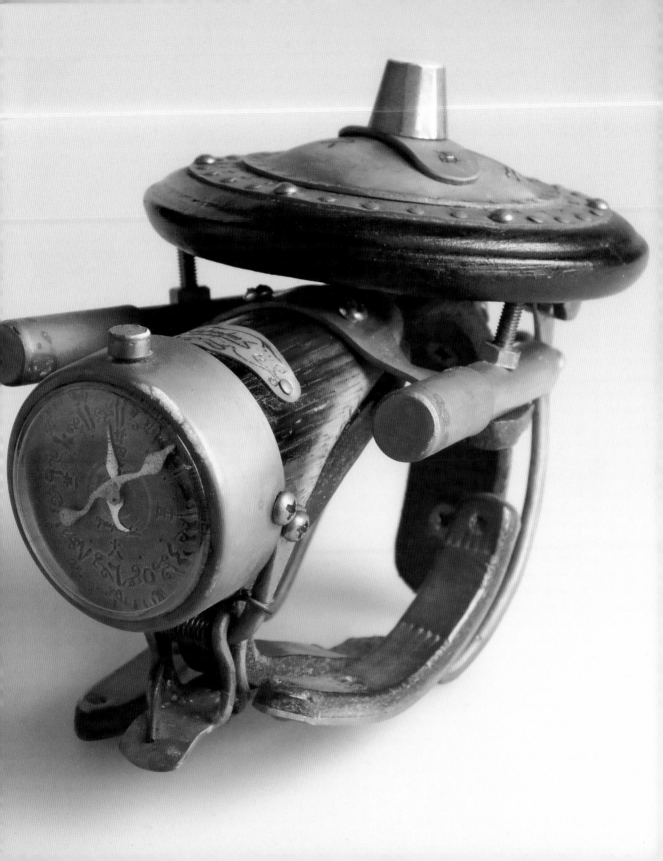

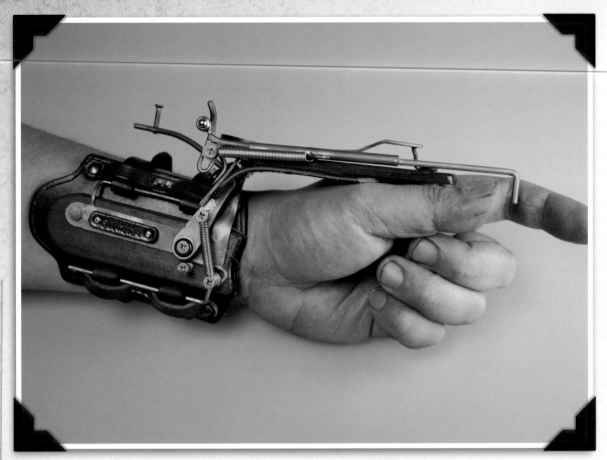

108

This Page *Rubber Band Gun*, 2010, 6" x 4" x 3" (160 mm x 110 mm x 80 mm), brass, leather, springs. Combining the functional and fun, this piece is both a watch and a toy.

Opposite *Energy Drink*, 2000, 6" x 3.5" x 3.5" (160 mm x 90 mm x 90 mm), brass, leather. This piece will hold a bottled or canned drink and can be worn around the waist on a belt.

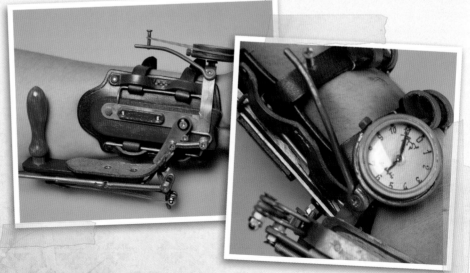

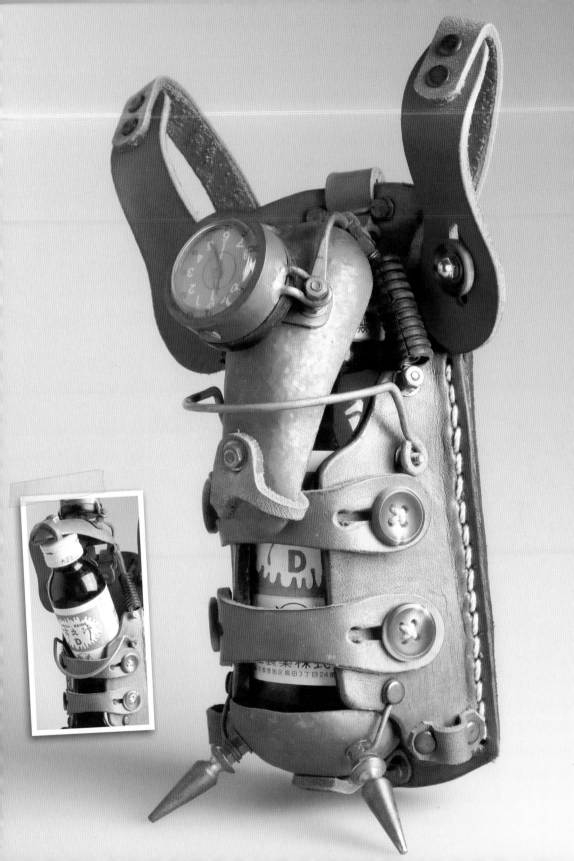

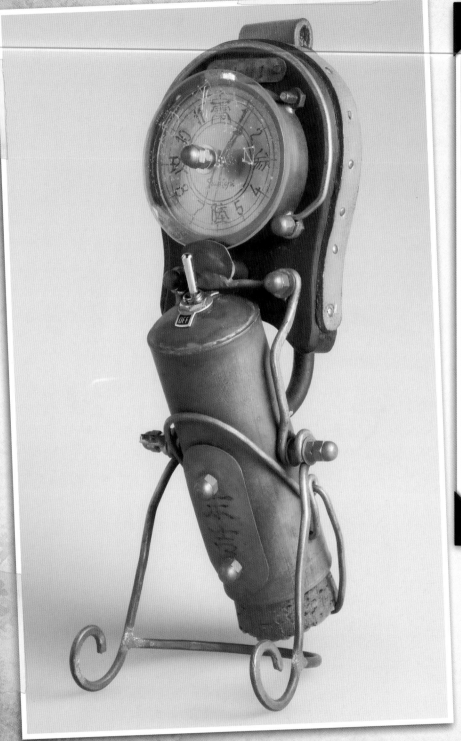

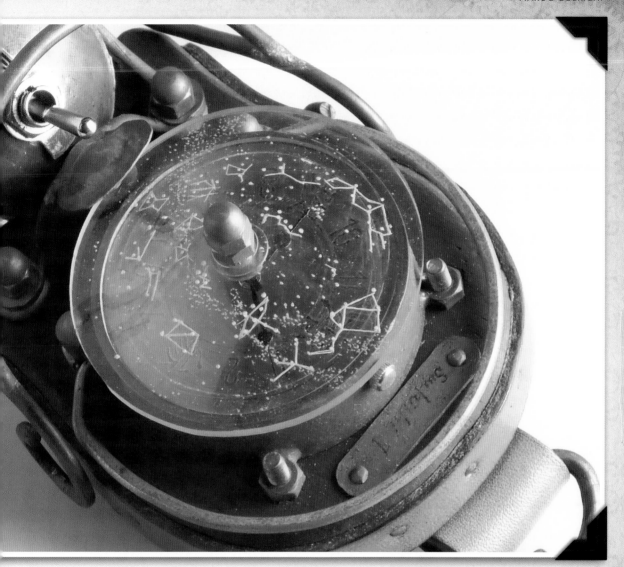

Star Watching-Galileo, 2008, 2" x 3" x 2" (50 mm x 80 mm x 50 mm), brass, leather. Suekichi's creation acts as a small planetarium, tracking the movements of the planets and stars. It can also be worn around the waist on a belt.

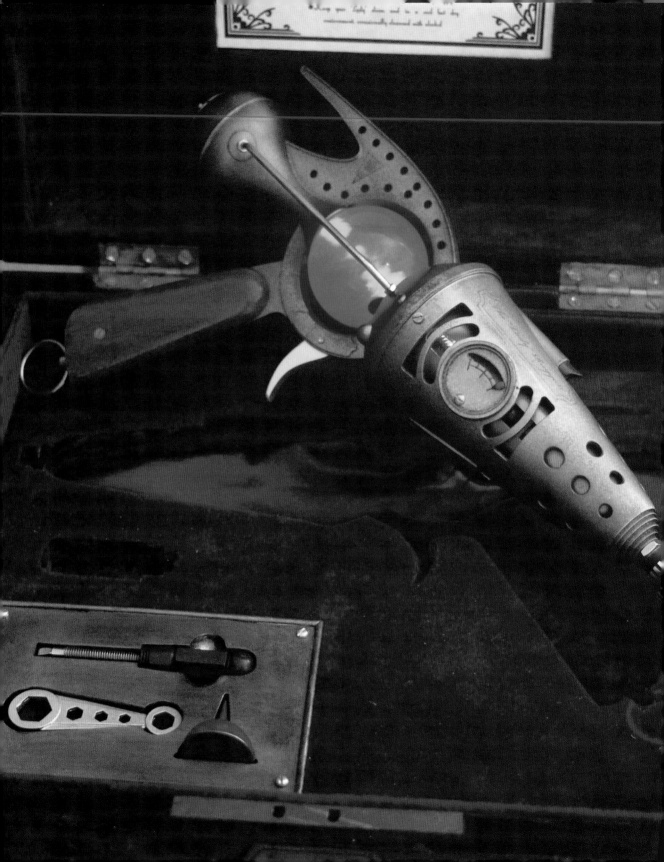

Ian Crichton

HERR DÖKTOR
Woking, Surrey, United Kingdom

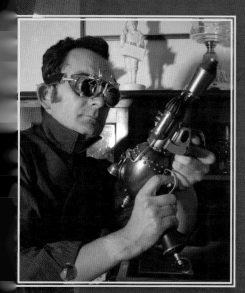

From his secret laboratory in the Home Countries, Ian Crichton, a.k.a. Herr Döktor, attempts to recreate the modern world as it should have been—in riveted brass, burnished copper, polished leather, and blown glass.

Crichton is a freelance prop and model maker whose commercial work includes action figures from *The Simpsons* and *Doctor Who*, along with a range of props and vehicles from the worlds of Gerry Anderson. Examples of his work for museums and exhibitions can be found around the globe.

Crichton's interest in Steampunk style comes from his love of history and speculative science fiction—the worlds of Verne and Wells, the engineering of Brunel, and the displays of The Great Exhibition.

He hopes you will enjoy his creations as much as he enjoys producing them.

Opposite
The Lady Raygun, 2010, 12" x 14" x 5" (350 mm x 355 mm x 130 mm), brass, wood, velvet, acrylic, steel, aluminum. *The Lady Raygun* was a commissioned piece that includes machined aluminum and brass accessories, with an illuminated interior and glowing power sphere.

113

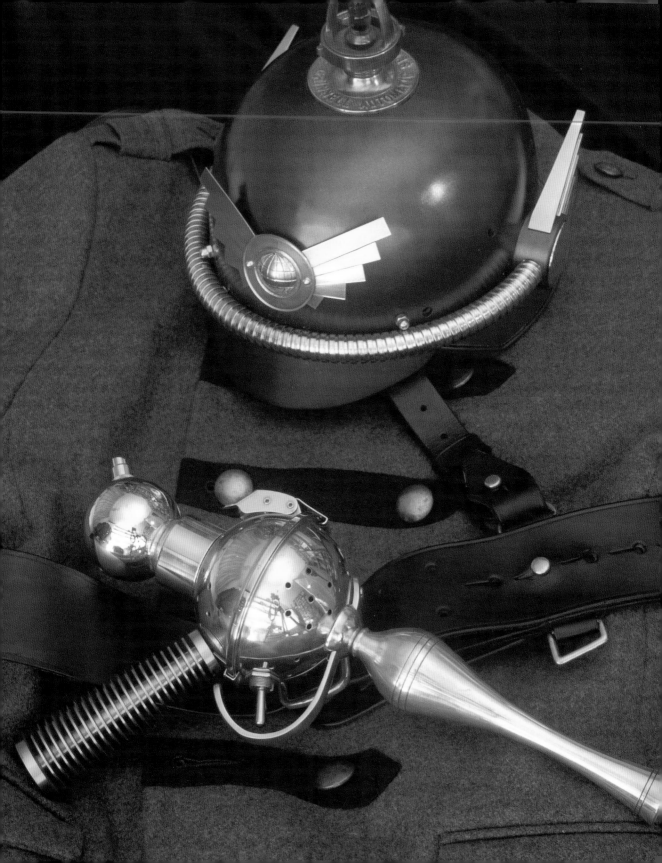

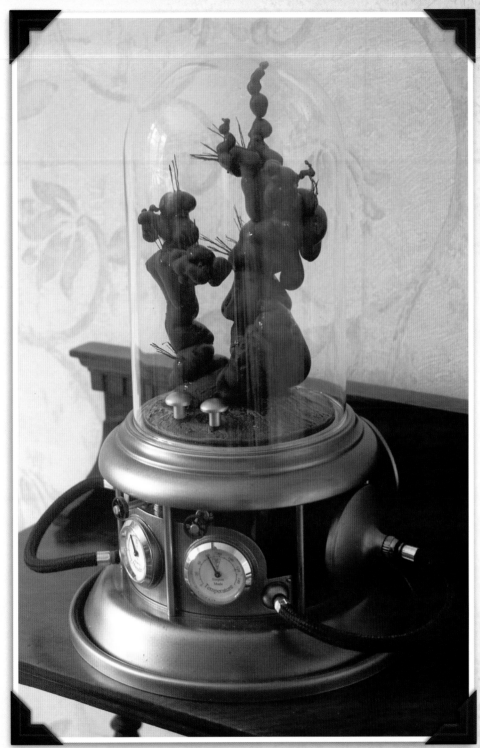

Opposite *Airship Commander Helm* and *Help the Aged Pistol*, 2009, Helmet: 10" x 9" x 9" (255 mm x 230 mm x 230 mm),, glass fibre composite, steel, brass, found objects. Pistol: 13" x 8" x 3.5" (330 mm x 200 mm x 90 mm), repurposed found metal objects. Herr Döctor's helmet has a built-in fire extinguisher, a must onboard a hydrogen airship. His *Help the Aged Pistol* uses a pulsed electromagnetic burst from a coiled array to "punch" an assailant to the ground, minimizing the risk of fire.

Left *The Red Weed: Cruentus Ervum Stella Martis Vulgaris*, 2009, 20" x 8" x 8" (500 mm x 200 mm x 200 mm), brass, glass, polyurethane. The *Red Weed* is a combined display and filtration unit with motorized filter bellows. The machine is used to hold a surviving specimen of the common Martian Red Weed acquired from the common land of Surrey.

115

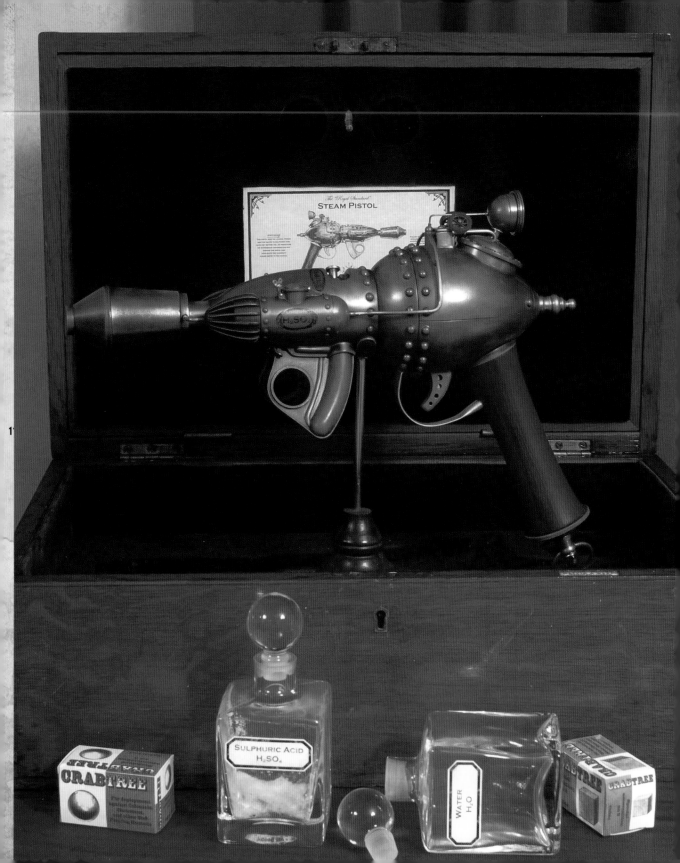

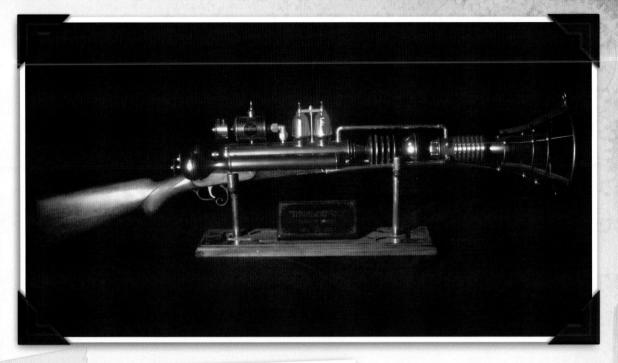

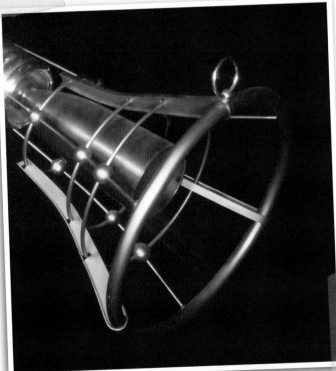

Opposite *Steam Pistol*, 2009, 12" x 18" x 6" (305 mm x 460 mm x 150 mm), acrylic, brass, steel, wood, velvet. Herr Döctor's *Steam Pistol* can propel a projectile at high speed using the steam produced from the desiccation of water. Two styles of projectile may be selected from the two magazines: spherical for your Earthly adversaries, and cubed for your un-Earthly opponents. The case for the pistol is a hardwood cutlery case from the royal company Mappin & Webb.

This Page *The Thunderbuss: A Gentleman's Sonic Hunting Rifle*, 2009, 41" x 12" x 7" (1040 mm x 305 mm x 180 mm), wood, brass, copper, steel, various synthetics. This piece was produced over the winter of 2008-2009 and contains working settings gauges labeled "Quiet, Loud, Louder, Pardon?" and "Wound, Hurt, Kill, Liquefy."

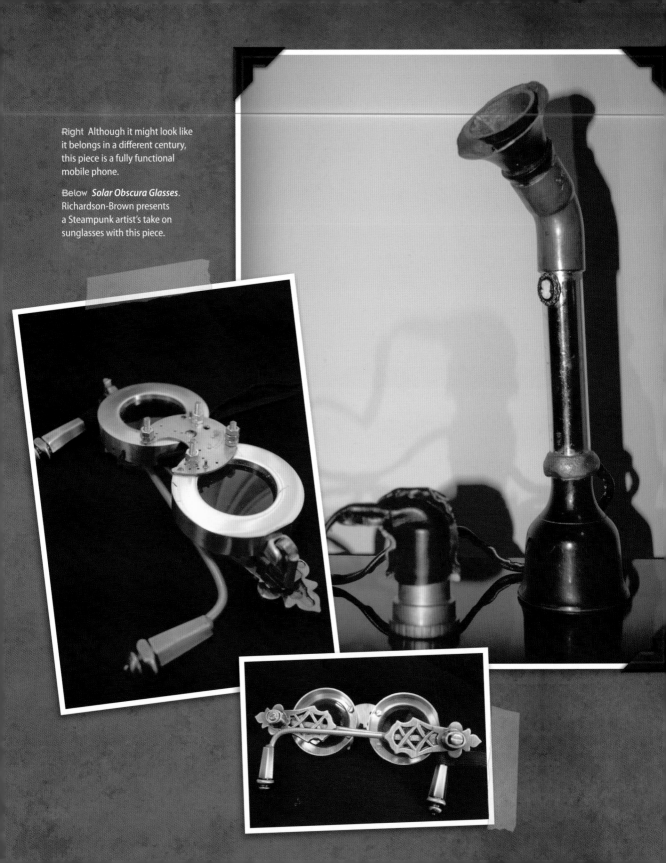

Right Although it might look like it belongs in a different century, this piece is a fully functional mobile phone.

Below *Solar Obscura Glasses*. Richardson-Brown presents a Steampunk artist's take on sunglasses with this piece.

James Richardson-Brown

CAPTAIN SYDEIAN
Southampton, Hampshire, United Kingdom

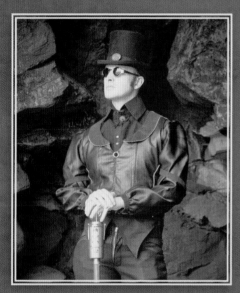

Photo by Ian Horner

Born in London in 1982, James Richardson-Brown showed no early interest in art of any kind, focusing his attention on scientific endeavors instead. It was Richardson-Brown's father, a draughtsman, who introduced him not only to science fiction literature, but also to the many links between art and science.

After an education focusing on scientific disciplines, Richardson-Brown began to pursue a career in information technology. As a hobby, he took up writing and creating visual 3-D art in a style that was then known to very few: Steampunk.

In 2007, Richardson-Brown started the UK's first Steampunk "meet-up," intending to create awareness of the style. This early event drew a crowd of three people. During the next two years, however, the event also began to grow. Recently, attendance hit one hundred people.

Since starting his artistic career, Richardson-Brown has published one book, *The Sydeian Coalition—A Steampunk Adventure* (co-written with Paul Taylor), and two articles. He has also had his 3-D visual art featured in various magazines and websites. As time goes on, Richardson-Brown is planning to find a publisher for his writing and to continue to create 3-D visual art to entertain and enthrall.

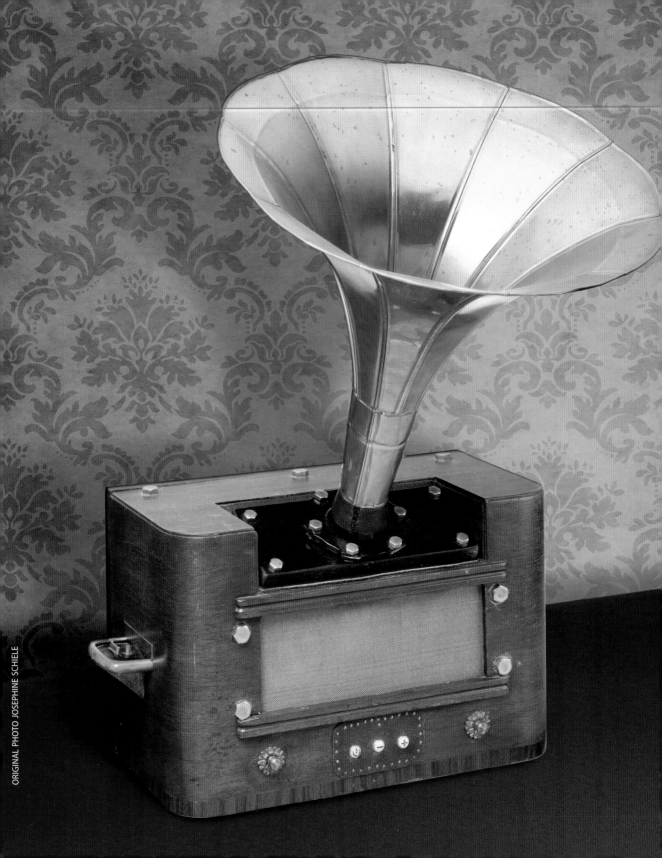

Jesse Newhouse

New York, New York, United States

Photo by Gregg Delman

Opposite
Gramophonobox MKII,
2008, Sony sound dock
and iHome parts, old
radio parts, brass bolts,
brass phonograph horn.
The *Gramophonobox*
is an iPod dock that
produces the same
sound quality as the
most modern of speaker
systems. Newhouse
only builds iPod docks
because he enjoys the
ironic juxtaposition of the
sleek modern iPod (the
antithesis of Steampunk)
and his elegant
handcrafted housings.

Jesse Newhouse was born in Manhattan under a full moon on Friday the thirteenth in 1976. In 1994, he went to the University of Colorado in Boulder and studied math before returning to New York. He briefly studied film at The New School, then left for Los Angeles in 2001. There, he worked his way up through the ranks of film production. Today Newhouse is back in New York City producing films for the SyFy channel under Paradox Pictures, along with his long-time business partner, Brandon Hogan.

Newhouse's love of Steampunk began with the *Myst* video game series, created by Robyn and Rand Miller in 1991. Since then, Steampunk has grown to be a passion. Newhouse has always loved model building and working with his hands. He never dreamt of being an artist, but is committed to doing his part for the Steampunk movement.

Newhouse has one sister, two very supportive parents, a loving wife, and a beautiful baby girl, who recently turned six months old.

123

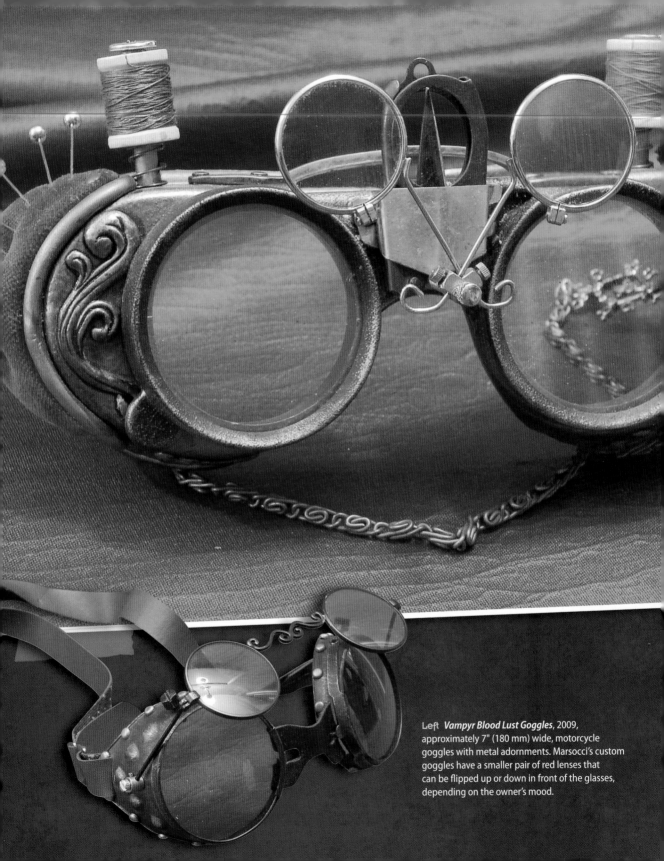

Left *Vampyr Blood Lust Goggles*, 2009, approximately 7" (180 mm) wide, motorcycle goggles with metal adornments. Marsocci's custom goggles have a smaller pair of red lenses that can be flipped up or down in front of the glasses, depending on the owner's mood.

Joey Marsocci

DR. GRYMM
Hartford, Connecticut, United States

Photo by Ajar Communications

Opposite
The Whole 9 Yards Goggles, 2008, approximately 8" (200 mm) wide, welding goggles, various pieces of sewing equipment. These custom-made goggles hold pin cushions, a pair of folding scissors, interchangeable bobbins, pins, and magnifiers.

Joey Marsocci, a.k.a. Dr. Grymm, graduated from California Institute of the Arts with a BFA in Film and Animation and has been a freelance designer of theme park attractions, toys, puppets, graphic marketing products, film props, and private consignments for more than eighteen years.

Marsocci's company, Dr. Grymm Laboratories, currently provides custom designs of props and creatures for film production companies across the United States. Marsocci's custom contraptions and sculptures, such as his world-famous Steampunk "Eye-Pod" Victrola have been seen in Steampunk exhibits and publications around the world, including the Steampunk Exhibit held at Oxford University's Museum of the History of Science in 2009–2010.

In the summer of 2009, Marsocci hosted and curated the first annual Steampunk Bizarre in Middletown, Connecticut. The event was so popular that the Third Annual Steampunk Bizarre will be held at the Mark Twain House Museum in Hartford, Connecticut, in October 2011.

Marsocci has two books scheduled for publication in 2011: *1000: A Steampunk Collection* and *How to Draw Steampunk*.

For more information about Marsocci and his Steampunk art, please visit *www.DrGrymmLaboratories.net, www.DrGrymmLaboratories.com*, and *http://steampunkbizarre2010.blogspot.com*.

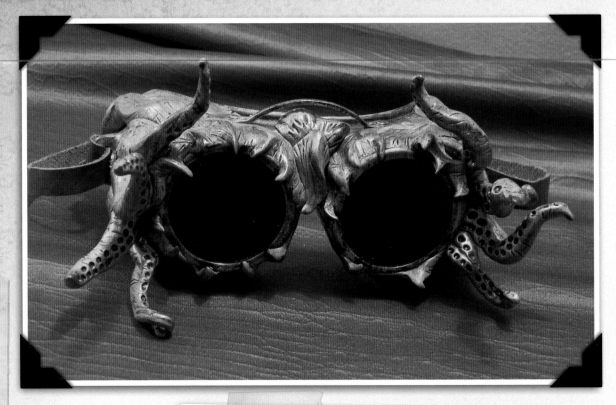

Above
Squid Attack Goggles,
2009, approximately 8"
(200 mm) wide,
hand-sculpted with
epoxy. These tentacled
glasses were inspired
by Jules Verne's *20,000
Leagues Under the Sea*,
and are a partner
to Dr. Grymm's
Nautilus Goggles.

Right
The Nautilus Goggles,
2009, approximately
8" (200 mm) wide,
hand-sculpted with
epoxy. These goggles
are meant to be
paired with the *Squid
Attack Goggles*.

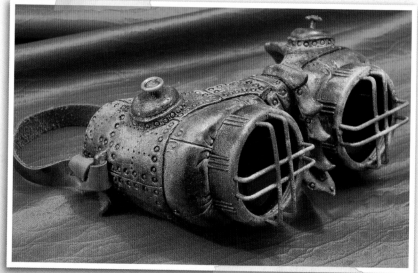

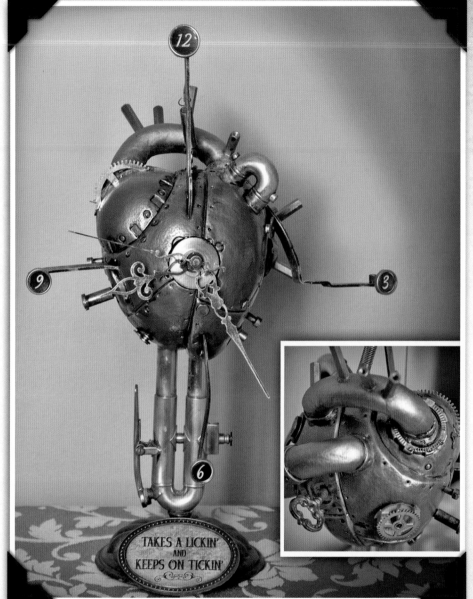

Left *Dr. Grymm's Clockwork Heart*, 2008, approximately 14" (355 mm) tall, found materials. Dr. Grymm created this piece in the memory of Allan DeBlasio. It was first displayed at the Steampunk Bizarre Exhibit in Connecticut.

TAKES A LICKIN'
AND
KEEPS ON TICKIN'

PHOTO BY JESSICA DUCKETT

This Page
Victrola Eye-Pod, 2008, approximately 9" (230 mm) tall, sculpture, found materials. This unique machine is a modded iPod Nano with a docking station that contains a USB charger. The iPod's menu is controlled by the pressure plate on the eye Dr. Grymm has added.

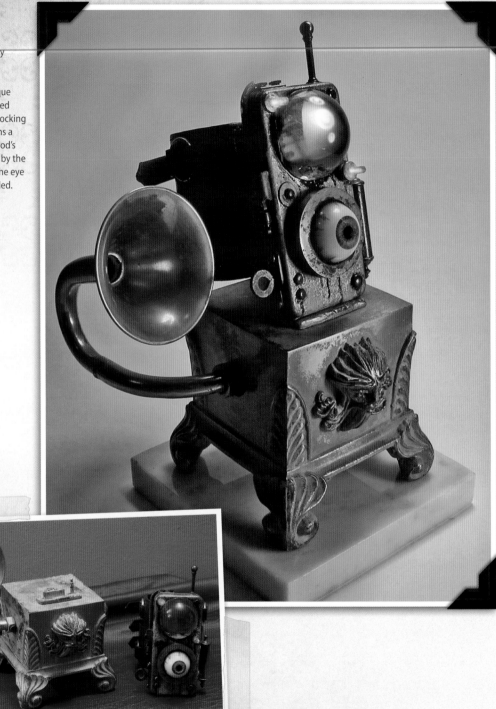

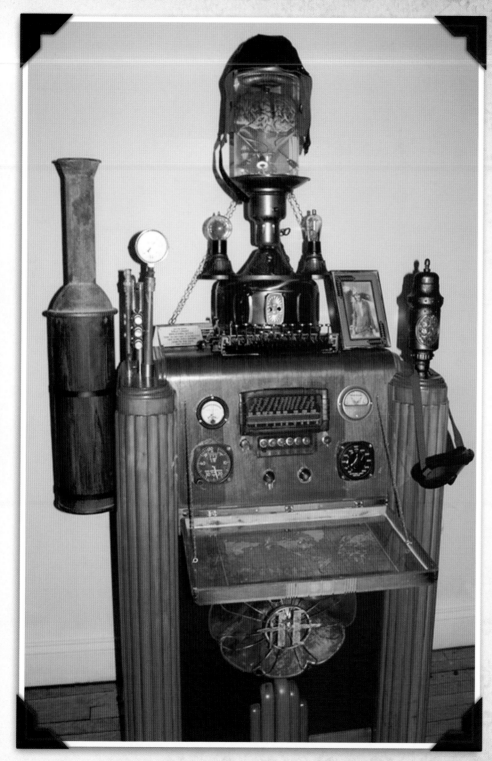

Left *The Amelia Earhart Navigational System*, 2009, approximately 6' (1830 mm) tall, found materials dated from 1920 to 1932. Dr. Grymm's functional audio interactive machine replicates the sights and sounds of Amelia, providing navigational instructions to various global paranormal locations from beyond the grave. The machine holds a brain in bubbling liquid, emits "steam," uses lighting effects, and has interactive typing and control panels. Machine design by Dr. Grymm, sound effects by Mark Adams Sound Design, voice of Amelia Earhart portrayed by Pamela Vanderway.

129

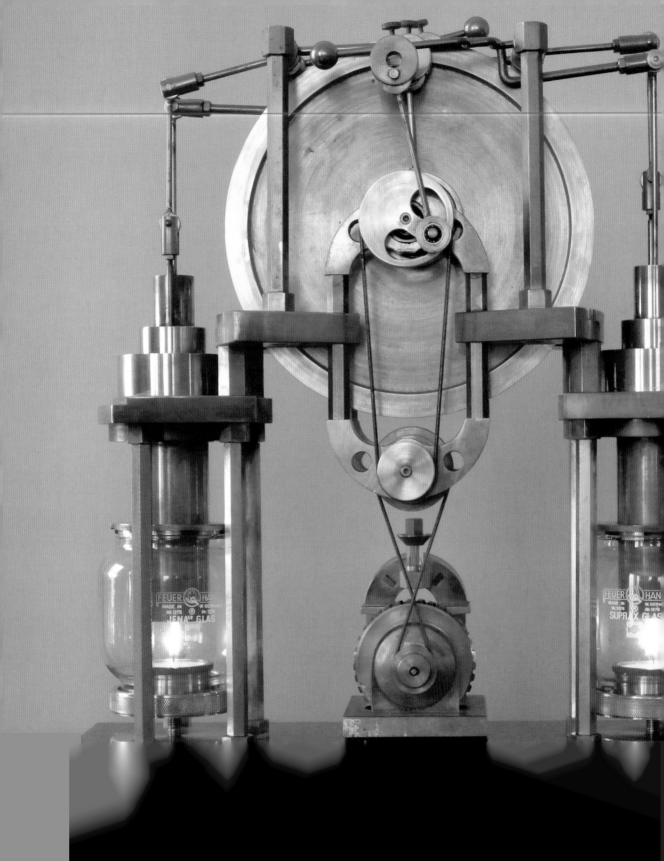

Jos de Vink

Bovensmilde, Netherlands

After retiring from a career in computer technology, Jos de Vink still had a desire to learn and create. De Vink's neighbor, who was an ardent model builder, challenged him to create a hot air engine that ran only on a tea or wax light. With help from this neighbor and colleagues in the Metaalhobbyclub Assen, de Vink built a trial engine using the principles of the first hot air engine built by Robert Stirling in 1816.

After receiving positive responses about his engine from members of the hobby club and others at a model exhibition in the Netherlands in 2002, de Vink to began to build more.

De Vink has created about twenty-seven engines in eight years and has started construction on several Stirling low temperature difference (LTD) engines that can run off the warmth of the human hand.

De Vink designs his engines from scraps of brass and bronze from a scrap dealer. The machines demonstrate the possibility of moving large objects using little energy and show different drive techniques used by hot air engine builders for the past two centuries.

Beyond having a passion for creating Steampunk kinetic art objects,

Photo by Hannie de Vink Henstra

Opposite *Cathedral*, 2004, 15" x 7" x 18" (380 mm x 180 mm x 450 mm), brass, bronze, marble. De Vink's *Cathedral* is not one engine, but two. This made its design and construction one of the biggest challenges de Vink has ever

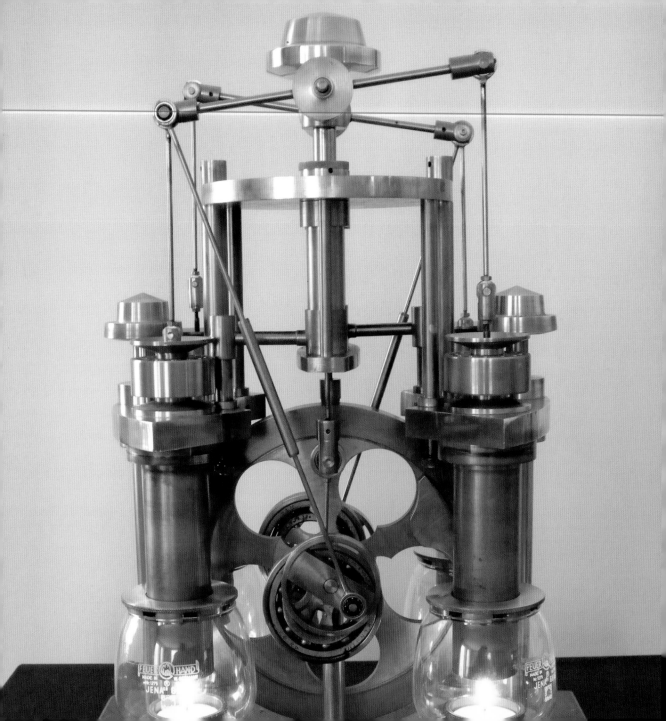

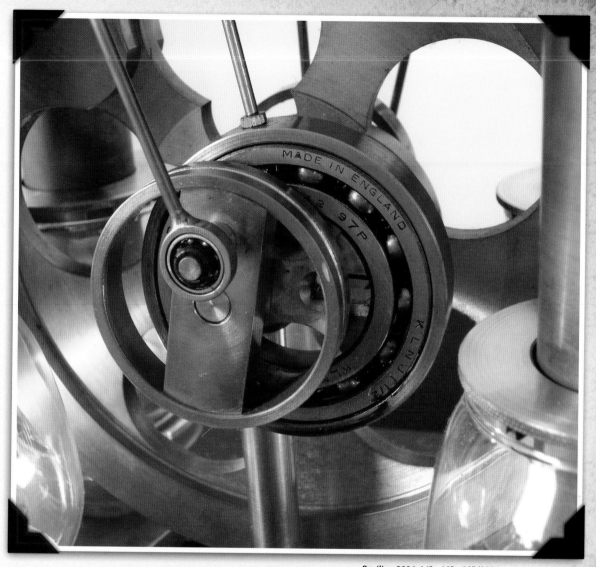

Basilica, 2004, 14" x 10" x 20" (350 mm x 250 mm x 500 mm), brass, bronze, marble. While the *Cathedral* consists of two engines, the *Basilica* consists of four. De Vink carefully arranged the engine components so that no one engine would be working harder than another. The result is an incredibly quiet machine. De Vink also developed a cooling system so the engine could run for eight hours on four tea warmers during an exhibition.

133

134

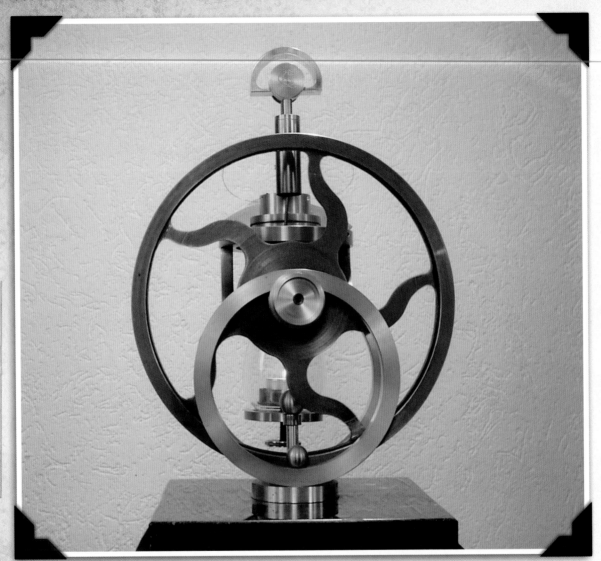

This Page *Peacock*, 2007, 12" x 13" x 16.5" (300 mm x 340 mm x 420 mm), brass, bronze, marble. The *Peacock* was modeled after the Ringbom Stirling engine. De Vink's challenge for this project was to make the large heavy flywheel rotate using just the heat of a tea warmer.

Opposite *The Flying Saucer*, 2008, 12" x 8" x 14" (300 mm x 200 mm x 360 mm), brass, bronze, stainless steel, Plexiglas. This piece combines three low temperature difference (LTD) engines.

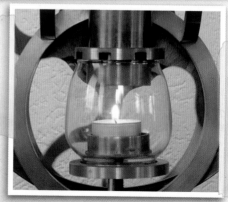

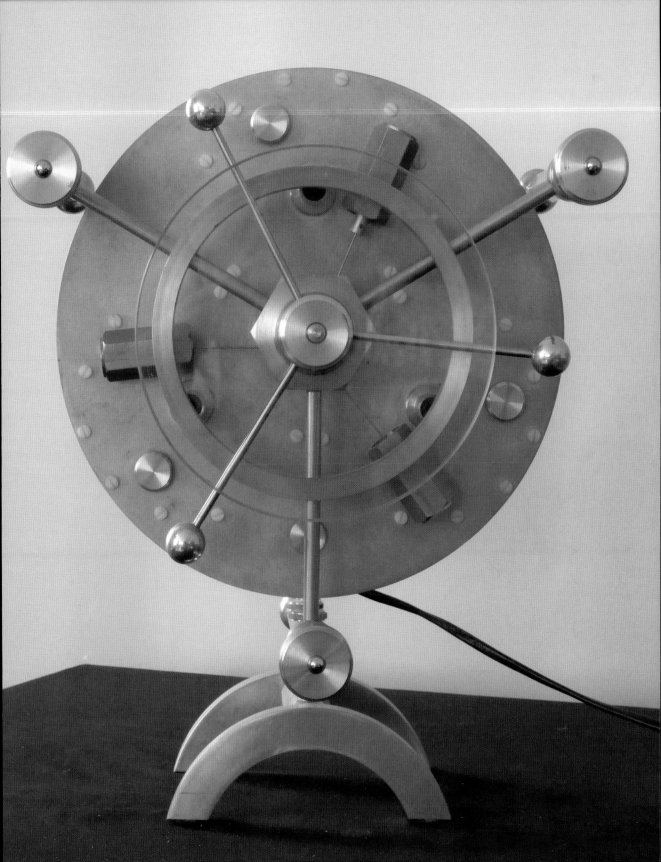

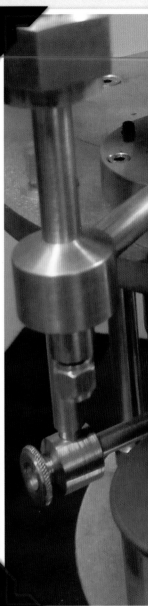

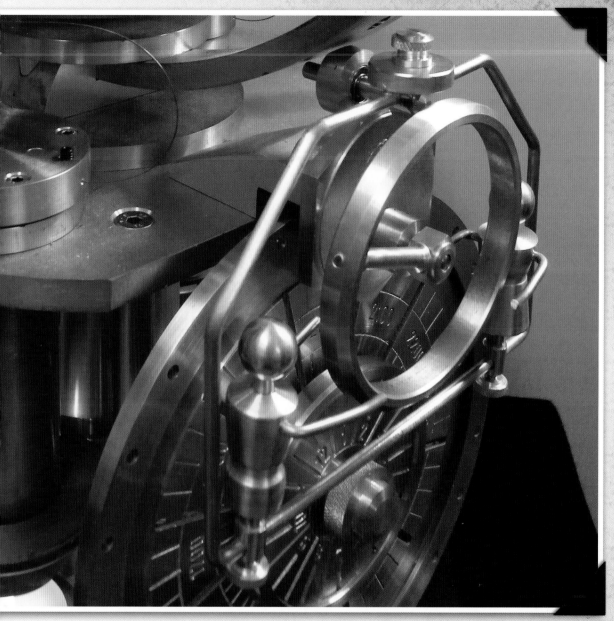

The Time Machine, 2010, 16" x 16" x 27" (400 mm x 400 mm x 680 mm), brass, bronze, marble. *The Time Machine* was inspired by some of the instruments de Vink saw at the Museum of the History of Science. It is a combination of two Ringbom engines and cleverly uses springs to reduce the weight of the displacer, allowing the engines to run on a tea warmer or a 20 watt halogen bulb.

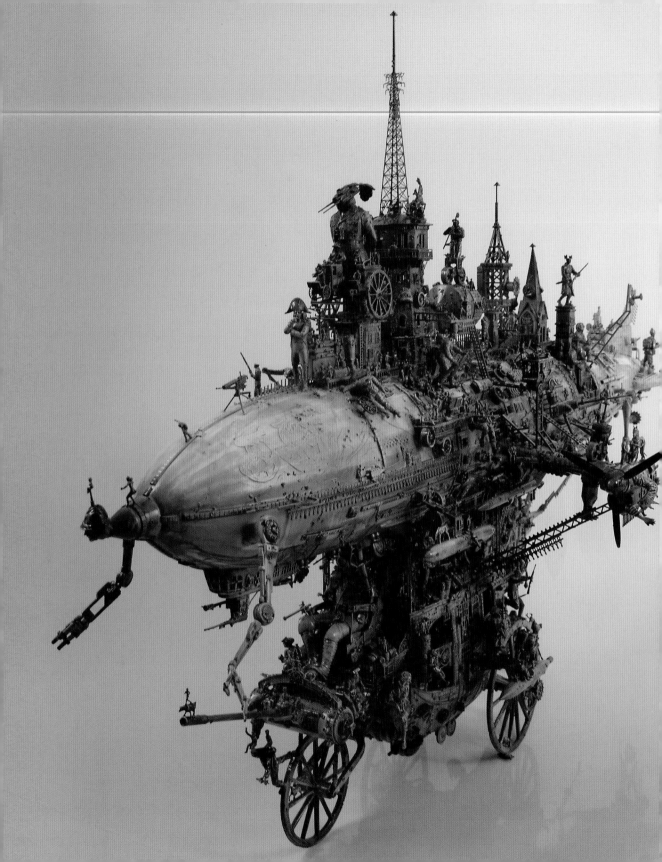

Kris Kuksi

Hays, Kansas, United States

Photo by Brandon Worf

Opposite *Caravan Assault Apparatus*, 2009, 28" x 20" x 39" (710 mm x 510 mm x 990 mm), mixed media.

Kris Kuksi's designs are inspired by many things, like the rigidity of machinery and networks of pipes and wires, along with the flowing, graceful, harmonious, and pleasing designs of the Baroque and Rococo periods. And he always strives to add a bit of weirdness or the macabre.

Kuksi had a major emphasis in painting and drawing earlier in his career, and while he enjoyed these forms of creativity, he knew there was something missing. Kuksi recognizes that he has always been a builder, and the creation of his 3-D art is his way of expanding into that realm. He still enjoys painting and figurative work, but he has made sculpture his primary focus.

He says, "Sculptural works are wonderfully intricate constructions of pop culture effluvia like plastic model kits, injection molded toys, dolls, plastic frames, or furniture parts, assembled into grotesque tableaux that look a bit like an explosion in Hieronymus Bosch's attic."

Kuksi has won several awards for his art, and his pieces have been featured in more than one hundred exhibitions, in various art magazines, and on book covers. His pieces reside in the collections of such notable public figures as Guillermo del Toro, director of *Pan's Labyrinth* and *Hellboy;* Fred Durst, musician and film director; Chris Weitz, director of *The Golden Compass* and *American Pie;* Mark Parker, Nike CEO; and Robin Williams, comedian and actor.

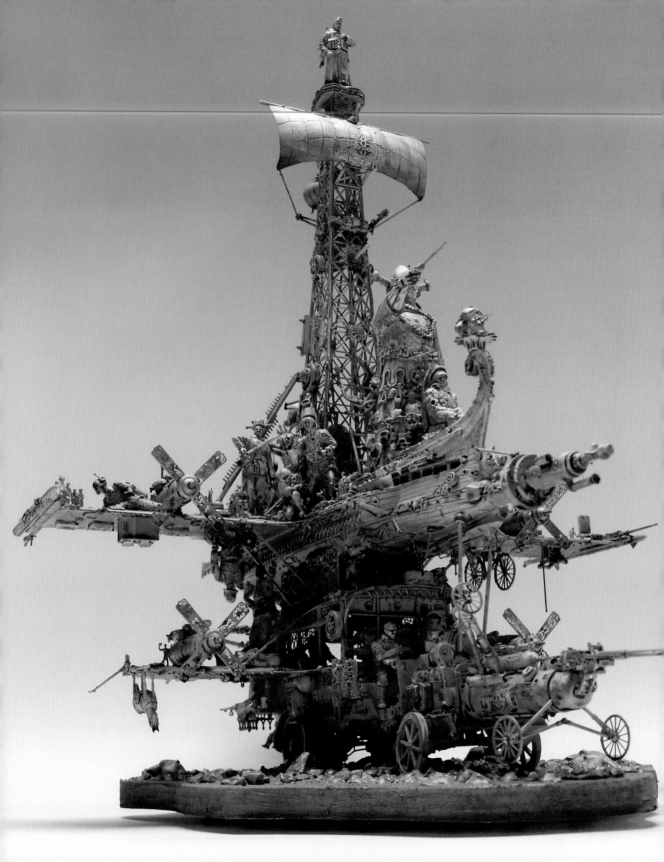

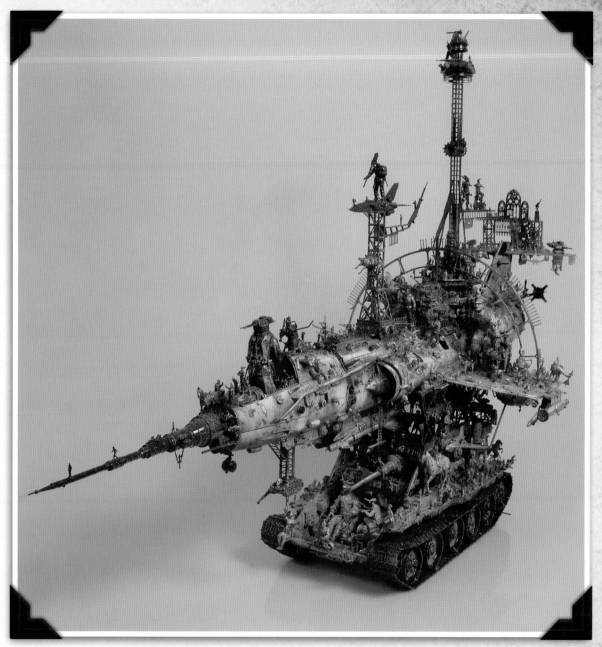

141

Opposite *Anglo Parisian Barnstormer*, 2009,
18" x 14" x 17.5" (710 mm x 320 mm x 1040 mm),
mixed media.

Above *Sub-sonic Dissidence Propulsion Device*,
2008, 28" x 17.5" x 41" (460 mm x 355 mm x 445 mm),
mixed media.

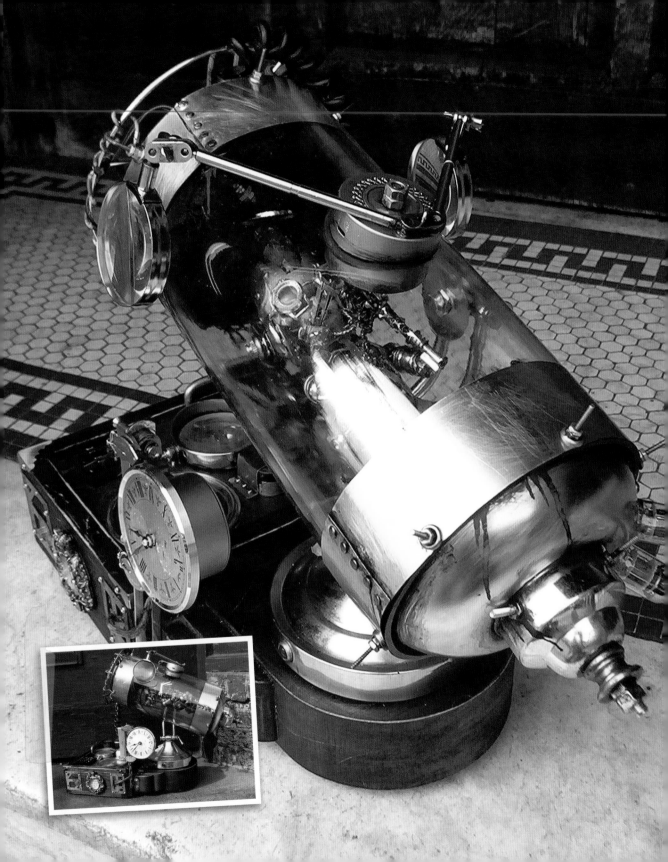

Molly Friedrich

PORKSHANKS
Seattle, Washington, United States

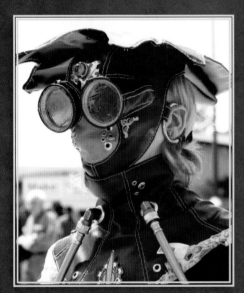

Opposite *Mechanical Womb with Clockwork Fetus*, brass, nickel, steel, copper, acrylic, rubber, plastic, glass. *The Mechanical Womb* explores the possibilities of future technology.

Molly "Porkshanks" Friedrich was born in Brookfield, Wisconsin, in 1975 and attended the Milwaukee Institute of Art & Design and the Minneapolis College of Art & Design before deciding to find her own path as an artist.

Friedrich's work has been noticed by many. She has been interviewed regarding her dimensional travels and her art by the *New York Times*, *Weird Tales*, the *Boston Phoenix*, *Aether Emporium*, the *Gatehouse Gazette*, *BoingBoing*, *Gizmodo*, *Make*, and many others. She has also written articles for websites such as *steampunkworkshop.com* and *instructables.com* and has been honored to create art for the bands Abney Park, Mungus, The Georgetown Orbits, and for the musician Michael Scott Parker.

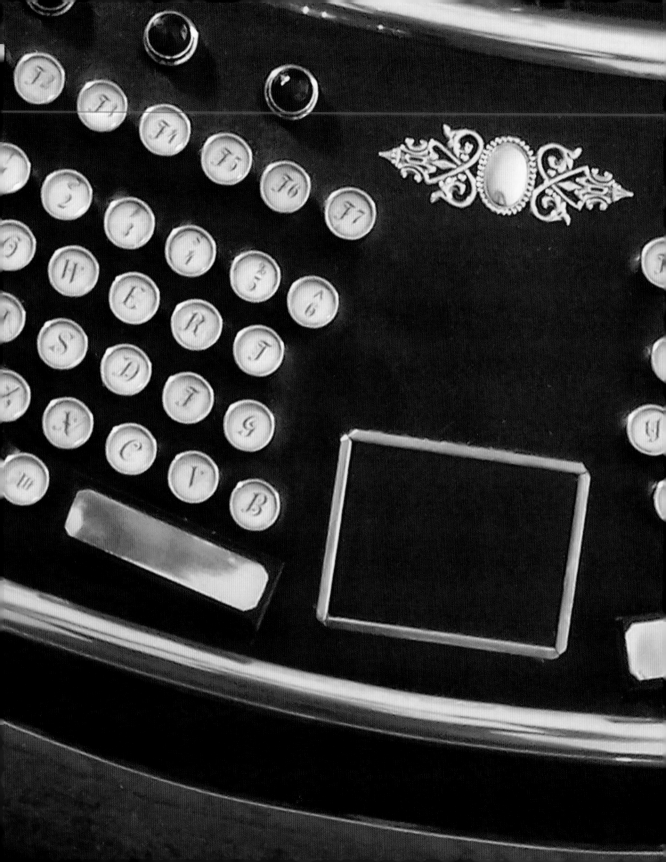

Richard Nagy

DATAMANCER
Chino, California, United States

"Datamancer" is the online nickname of Richard R. Nagy, a California-based artist and entrepreneur, and proprietor of *www.datamancer.net*. Over the last two years, Nagy has been slowly but steadily growing a business that sells Victorian and Art Deco computer hardware, including keyboards, mice, scanners, LCD monitors, and even full PC suites. Although he primarily works with computers, Nagy likes to dabble in almost every medium of design. His work has been featured in the *Wall Street Journal*, *Newsweek*, the *New York Times*, *Maxim*, *IEEE Spectrum*, *Forbes*, the *Boston Globe*, and in dozens of other publications in the United States and abroad. Nagy's work has also been featured on hundreds of Internet sites, including *BoingBoing*, *Gizmodo*, and *Makezine*.

Opposite *Datamancer Ergo Keyboard*, 2009, 23" x 14" (585 mm x 355 mm), brass, leather, typewriter keys. Richard Nagy's elegant *Ergo Keyboard* features acanthus-leaf etchings in the solid brass frame, a black leather faceplate, and padded velvet wrist rests.

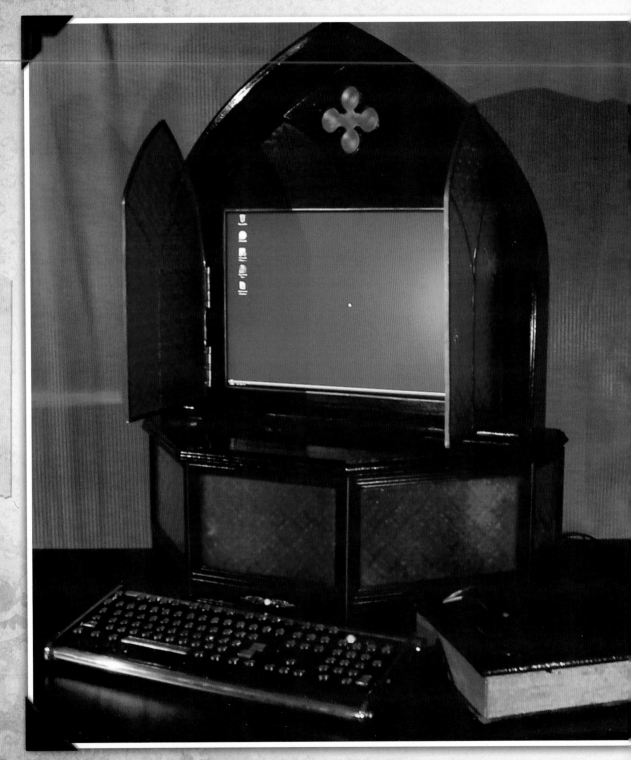

Opposite
The Archbishop, 2008, 28" x 20" x 36" (710 mm x 510 mm x 915 mm), stained glass, lead, wood, brass. Drawing inspiration from cathedral architecture, this full PC suite includes a custom PC enclosure made of wood and stained glass, an LCD with a gothic arch shape and stained-glass doors, and a gothic-themed keyboard.

Left *PC and LCD Combo*, 2010, 24" x 24" (610 mm x 610 mm), brass, leather, typewriter keys. Pictured here is one of Datamancer's brass PC and LCD combos.

Below *Aviator Keyboard*, 2010, 19" x 8" (480 mm x 200 mm), aluminum, leather, typewriter keys, mechanical-switch keyboard. This is one of Datamancer's "Aviator" model keyboards.

147

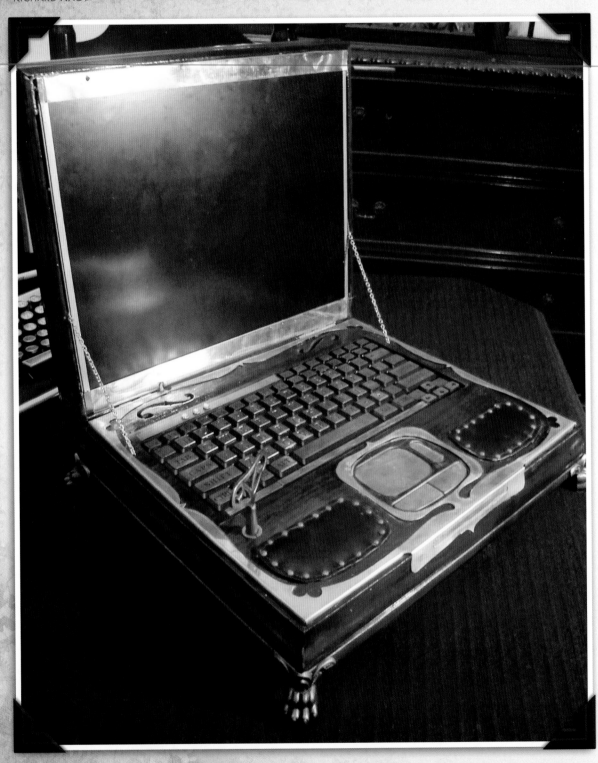

Opposite *Datamancer Steampunk Laptop,* 2007, 14" x 16" (355 mm x 405 mm), wood, brass, copper, clock gears, glass. This is a fully functional laptop with a Victorian twist. It features an array of clockworks under glass, engraved copper keys, leather wrist rests, and turns on with an antique clock-winding key.

Left *The Nagy Magical-Movable-Type Pixelo-Dynamotronic Computational Engine,* 2006, 48" x 36" (1220 mm x 920 mm), wood, Underwood typewriter, King radio cabinet, assorted PC components. One of Datamancer's earliest projects, the *Computational Engine* features a modified King Radio cabinet, flatpanel LCD, Singer sewing machine legs, and an Underwood typewriter rewired to act as a modern PC keyboard.

149

Stephane Halleux

Mohiville, Belgium

Photo by Muriel Thies

Opposite *Flying Man*, 2010, 39" x 43" x 20" (1000 mm x 1100 mm x 500 mm), mixed media.

Stephane Halleux has come to the conclusion that he does not have much to share about his work: no great theories, no subliminal messages, no great trade secrets. Instead, he will tell you that what he finds himself doing most often when he goes to create another Steampunk masterpiece is attempting to return to a time of childish innocence where anything is possible. It is in this state that ideas and concepts do not have to remain on paper, but can come alive and enter our universe, or any universe they please.

Halleux's life partner has told him she often hears him talking out loud or making strange noises when he is in his workshop. Halleux admits to this because, in reality, he does not work, he plays. That is not to say that nothing serious goes on in Halleux's workshop. He regularly examines and dismantles pieces, sorts through materials, and cleans up after himself, but when it comes to bringing life to his creations, Halleux allows his imagination to have full reign.

Halleux hopes that those who see his creations will enjoy traveling among them just as much as he enjoyed bringing them to life.

The Assistant

By Stephane Halleux

Once upon a late evening, while cleaning my workroom, I realized how useful an assistant would be—someone I could entrust with all the little tasks that were slowing down my work.

From an old spin dryer and an old German typewriter, I created a robot with pliers for a left hand and a blowtorch, cutting disk, and drill grafted onto its right hand.

This new companion quickly showed himself to be extremely gifted.

He executed any requested work so rapidly that I had great difficulty keeping him busy for more than a few minutes. He soon started to complain about my slowness in creation and low wingspan projects. I told him that things were not so obvious—I suffered from a lack of room, I had a family life. In fact, I'd like to see him try it. My wish was fulfilled right away. My assistant drew up new plans while I was running about looking for the materials he needed.

A couple of days later, while carrying out one of his numerous projects, he made me understand he would be able to work even faster if I relieved him of all the superficial tasks that prevented the true blossoming of his art. I had become my assistant's assistant!

I smothered him by filling his old spin dryer thorax with linen. Since then, I've been exhibiting his carcass and sweeping out my workroom late in the evening and whistling.

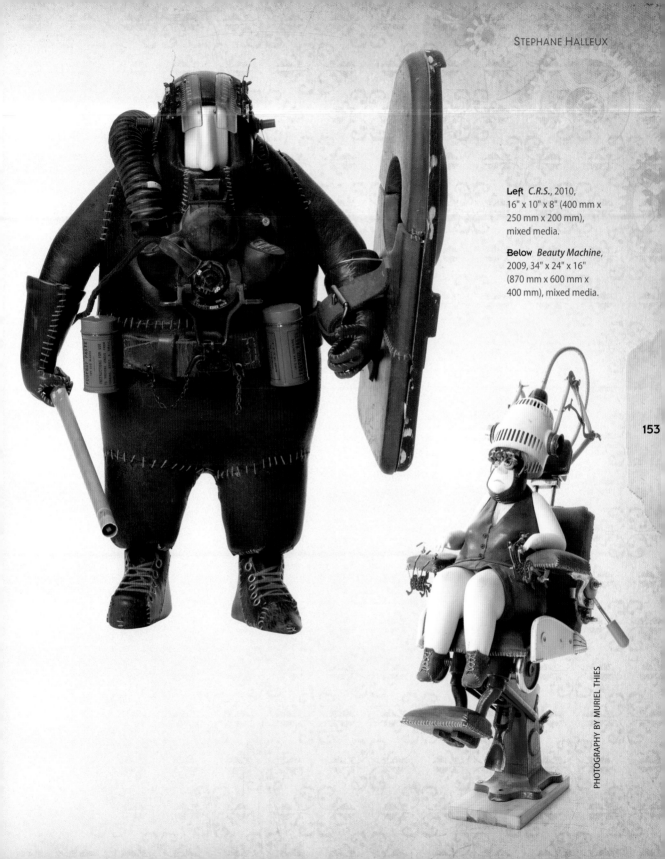

Left *C.R.S.*, 2010,
16" x 10" x 8" (400 mm x
250 mm x 200 mm),
mixed media.

Below *Beauty Machine*,
2009, 34" x 24" x 16"
(870 mm x 600 mm x
400 mm), mixed media.

153

PHOTOGRAPHY BY MURIEL THIES

154

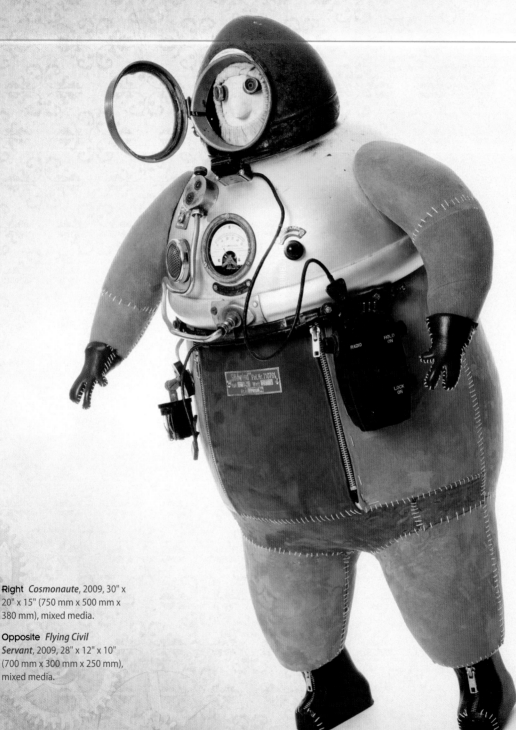

Right *Cosmonaute*, 2009, 30" x
20" x 15" (750 mm x 500 mm x
380 mm), mixed media.

Opposite *Flying Civil
Servant*, 2009, 28" x 12" x 10"
(700 mm x 300 mm x 250 mm),
mixed media.

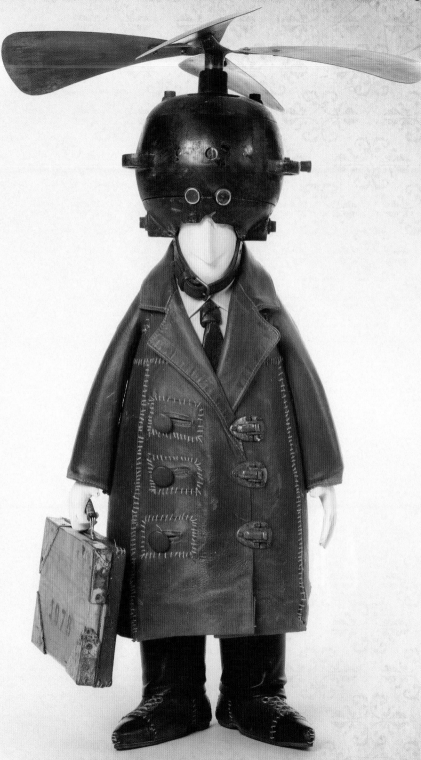

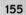

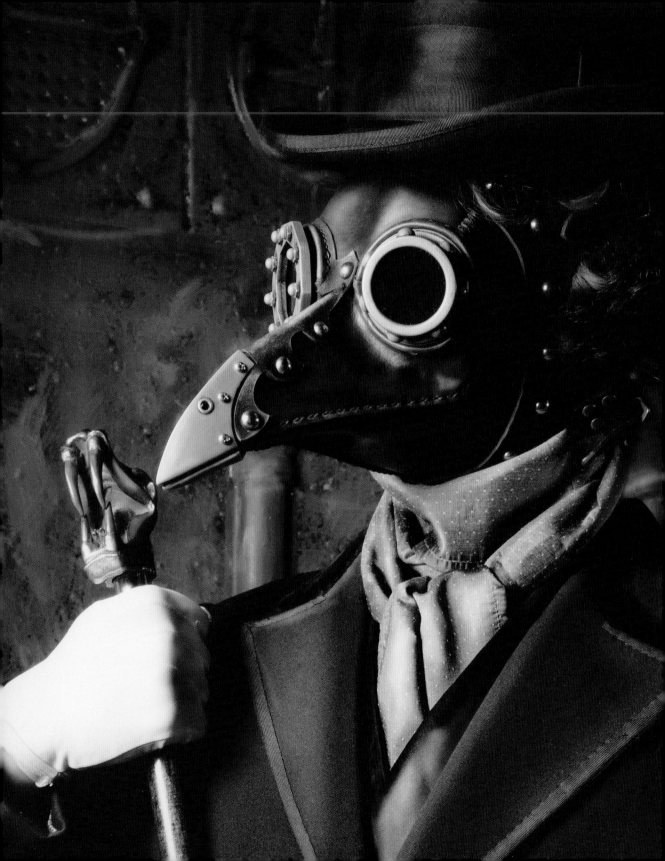

Tom Banwell

Penn Valley, California, United States

Photo by Topher
Adam Photography

Opposite **Dr. Beulenpest
Gas Mask**, 2010, leather
and cold-cast aluminum.
This mask is made to
imitate the classic plague
doctor mask.

Tom Banwell is a self-taught artist with no formal training who has dabbled in a variety of media, including batik, woodcarving, mixed media art dolls, and leather working. As a child, he was fascinated by helmets and other hats and would collect them.

As an adult, Banwell started a business designing, making, and selling men's Western leather hats. Later, he built another business casting custom resin pieces, which often required him to imitate other materials, such as bronze, marble, or wood with the resin. Banwell takes this past experience and incorporates it into his current Steampunk artwork.

Banwell finds that the Steampunk genre fits him exceedingly well, combining several of his interests—history, costuming, mechanics, and fantasy—with his creativity in leatherwork. Today, Banwell finds his greatest creative expression in fantasy masks and helmets.

157

158

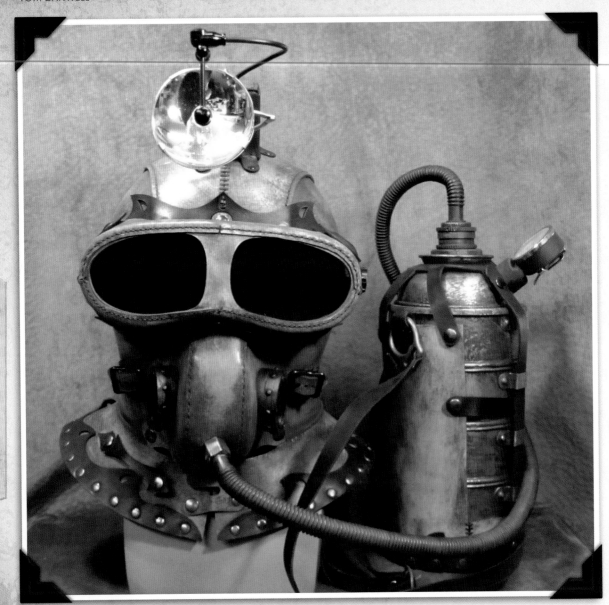

Above *Underground Explorer*, 2009. The backpack tank on this mask holds septoxygen, a dense liquid form of the life-giving element oxygen, which is made breathable by catalysts within the mask's snout-like face piece.

Opposite The *Underground Explorer* also features a head lamp and oil lamp that can be used without the mask.

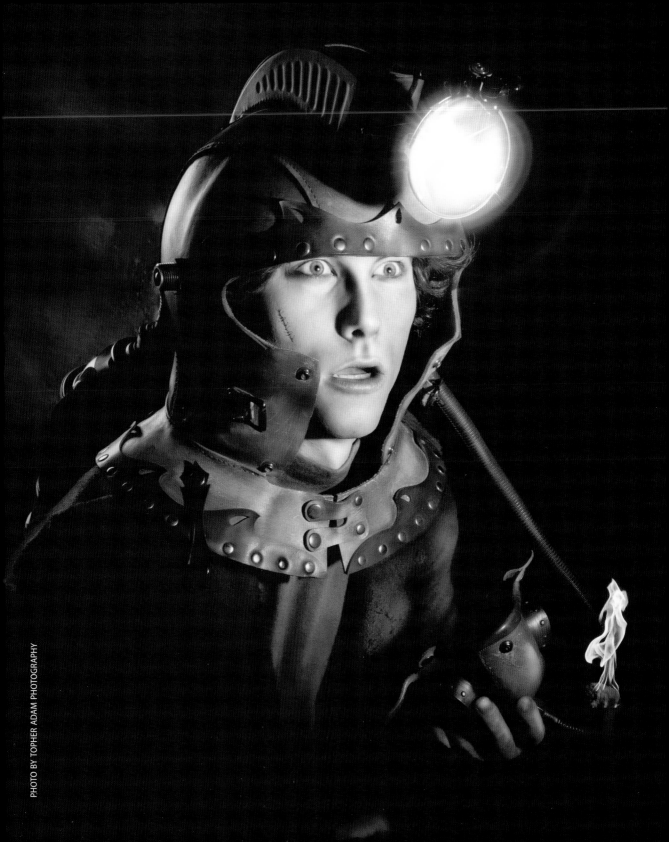

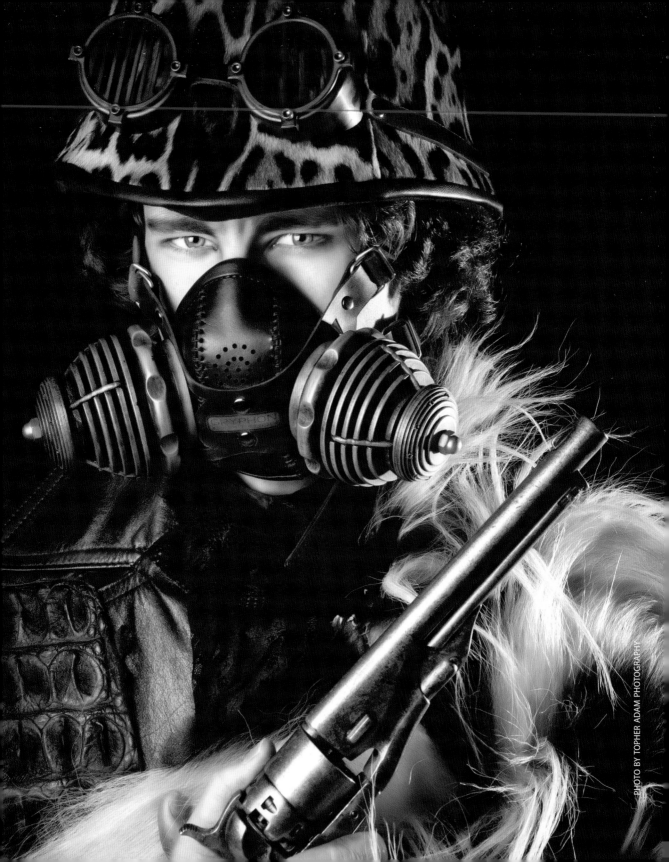

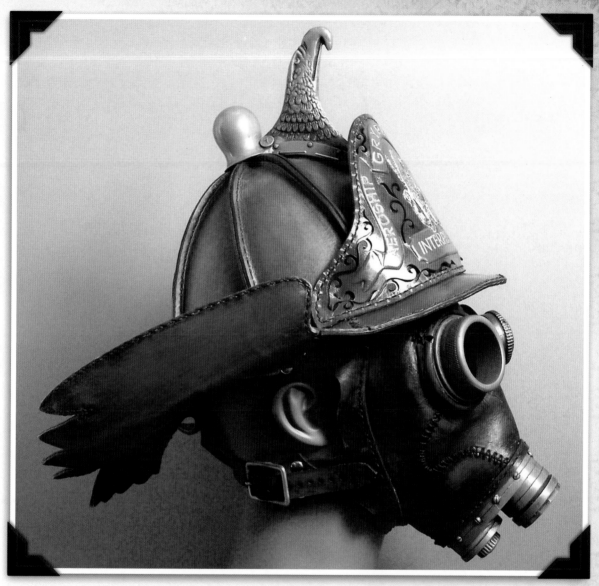

Opposite *Bad Air Transmutator* and *Pith Helmet*, 2008. The aluminum canisters on the *Bad Air Transmutator* make the air breathable for this adventurer. Goggles by Gothic Punk Specialty Hardware.

Above *Firemaster*, 2008. The *Firemaster* is composed of two pieces: the #43 gas mask and the *Firemaster's* helmet. The brim of the helmet reflects the shape of gryphon wings, while the "tall eagle" finial is similar to those sported by nineteenth century firefighters.

162

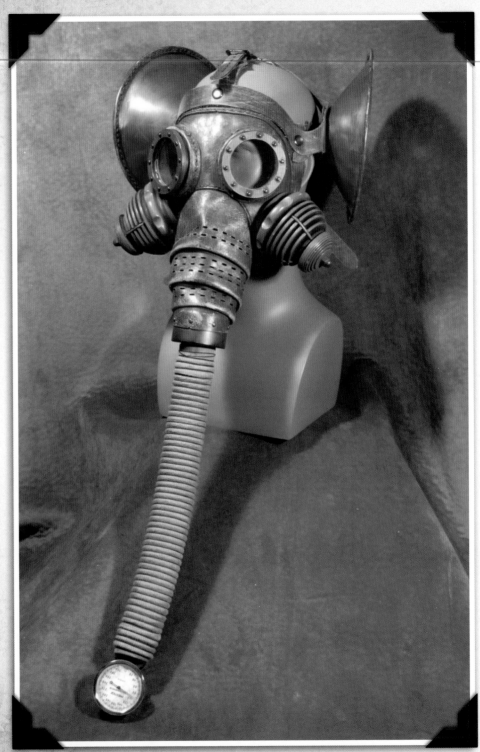

Right *Pachydermos Gas Mask*, 2009. To create this piece, Banwell covered a vacuum hose with leather.

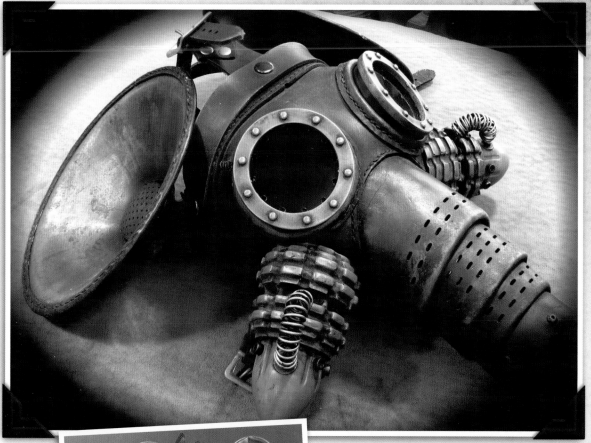

Above *Olifant Gas Mask* or *Son of Pachydermos*, 2010, cold-cast aluminum, leather, copper. This mask maintains many of the *Pachydermos Gas Mask's* features, but replaces the long trunk with a custom neoprene hose.

Left *Sentinel*, 2010, hand-stitched leather, cold-cast aluminum, metal auditory horn, lamp. Banwell's masks are inspired by the Gryphon Interplanetary Aeroship Expedition, a group of interplanetary explorers Banwell has created and outfitted for their adventures. This mask features the expedition's gryphon logo. The helmet, gas mask, and gorget are each separate pieces.

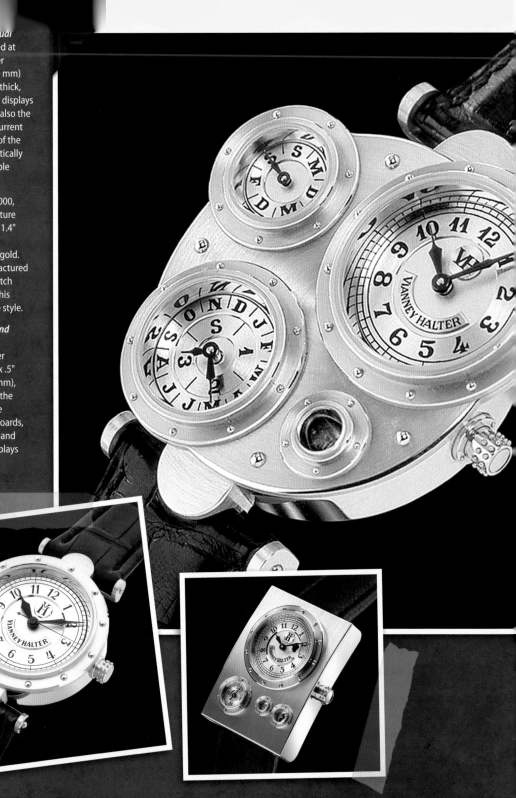

Right *Antiqua Perpetual Calendar*, 1998, created at La Manufacture Janvier (Sainte-Croix), 1.6" (40 mm) diameter, .5" (11 mm) thick, rose gold. The *Antiqua* displays not only the date, but also the day of the week, the current month, and the cycle of the leap year, and automatically accounts for the variable days of each month.

Below Left *Classic*, 2000, created at La Manufacture Janvier (Sainte-Croix), 1.4" (36 mm) diameter, .5" (11 mm) thick, yellow gold. Forty-six hand-manufactured rivets decorate the watch case, helping to give this piece its unclassifiable style.

Below Right *Trio Grand Date*, 2006, created at La Manufacture Janvier (Sainte-Croix), 1" x 2" x .5" (32 mm x 43 mm x 9 mm), rose gold. Inspired by the appearance of antique steam machine dashboards, Halter includes both hand analog and digital displays on this watch.

Vianney Halter

Sainte-Croix, Switzerland

Photo by
Bernard Cheong

Vianney Halter was born in Suresnes on the outskirts of Paris, France, in 1963. His father was a train driver for the Saint Lazare Railway Station.

In his oldest memories, Halter remembers his father bringing home old machines and mechanisms that fascinated him. Perhaps it was this early exposure to powerful locomotives, steam engines, and control instruments that originated Halter's attraction to mechanics and engineering.

Halter was only fourteen years old when he took the train to the capital to enroll himself at the Paris watch making school.

In 1998, Halter presented a strange watch baptized *Antiqua Perpetual Calendar* at the Basel Fair. This was immediately regarded as a "relic of the future" by the media, who were astonished by this new style.

The *Antiqua* was followed by the *Classic* in 2000 and the *Trio Grande Date* in 2006. These watches form the collection *Futur Anterieur* (past future). The collection is characterized by a display of various functions through riveted portholes.

INDEX

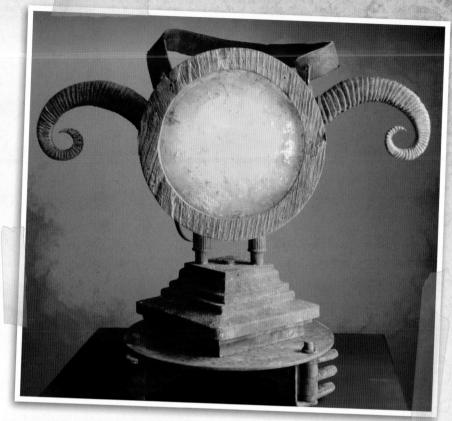

Steampunk Ram Horn Lantern, Art Donovan

Acquisition editor: Peg Couch
Copy editors:
 Paul Hambke, Heather Stauffer
Book Designer: Jason Deller
Editor: Katie Weeber
Proofreader: Lynda Jo Runkle
Indexer: Jay Kreider

More Great Books for the Artist & Craftsman from Fox Chapel Publishing

Steampunk Your Wardrobe
ISBN 978-1-57421-417-8 **$19.99**
DO5388

Hogbin on Woodturning
ISBN 978-1-56523-752-0 **$24.99**

Art of Ian Norbury
ISBN 978-1-56523-222-8 **$24.95**

Cigar Box Guitars
ISBN 978-1-56523-547-2 **$29.95**

Cigar Box Art Poster Book
ISBN 978-1-56523-743-8 **$24.99**

Labeling America: Popular Culture on Cigar Box Labels
ISBN 978-1-56523-545-8 **$39.95**

Traditional American Rooms
ISBN 978-1-56523-322-5 **$35.00**

New Masters of the Wooden Box
ISBN 978-1-56523-392-8 **$29.95**

History of Lovespoons
978-1-56523-673-8 **$14.95**